THE
MAGIC
OF
ACTING:

An introductory Primer to 'Being-ness'

Robert Goodman

Dedication

To the magical madness within all of us.

It's Playtime again.

How to read this book

This book should be read in the order presented, from beginning to end. If you want a book on how to act, this is *not* the book for you. However, if you want to transform your acting beyond your wildest dreams, then this could be the book for you!

Let me be clear from the start: this is not just another technical 'how-to' manual. I will not give you formulas or techniques; there are *hundreds*, possibly *thousands* of books out there that do this. All of that stuff is useless, anyway, if you don't engage with it in the right way. You need to *'receive'* from the right place within you; otherwise, it's merely clinical. So this is less a book about acting than one about connecting to the actor within. It is my intention in this little book to introduce you to your crazy magical self. It is from here that you will blossom as an actor. It's already there; it is a preset ability that you already have. Let's see if we can unlock it together.

Contents

Part one: The Magic of Acting

Introduction

From the first cave paintings and shamanic shadow dancing by firelight to mummers' plays and magical ritual, there has always been a strong connection between performance and the need to understand the metaphysical. If creativity and magic are inextricably linked, which I believe they are, then it follows that acting is a kind of magic and that we should inject a little more magic into our creativity and indeed a bit more creativity into our magic. Cold, empty imitations are simply not good enough.

One of the oldest religious texts in the world is the *Tao Te Ching*. Tao, pronounced 'Dow,' means 'the way' and the very first line of this text as translated from the ancient Chinese is:

The Tao that can be explained is not the Tao.

It is something beyond explanation. Rather, we must experience it as something inside of us — as part of the very fabric of our beings. It is not only in our physical DNA, but our very souls, whatever you understand 'soul' to mean. It is the essence of all that exists within everything.

I believe the true nature of creativity to be like the Tao. It is that which cannot be explained, but I do hope to help you experience for yourself what creativity in acting and indeed magic is. I want to help you experience the **Magic of Acting**.

With any of these esoteric or magical beliefs, the student must be ready to receive and engage with these teachings on various levels of understanding. At first, they might receive them on a fundamental level, which is very important. Still, a student needs to prepare the self to receive and engage on a deeper level, so that the teaching is not merely a superficial cerebral understanding, but rather an experiential thing where you just 'get it' inside, and where it is not full of analytical mind babble.

The same thing applies to acting. There are some (a *few*) brilliant actors, and anyone can be an excellent actor, but you have to be ready. You must awaken that part of you that will make your acting powerful, workable, and real.

By the way, let me make it clear at this stage that when I talk about magic, I am not — Ok? — *not* talking about some sort of cabaret act where a stage performer flourishes a couple of silk handkerchiefs or produces a rabbit out of a top hat. I'm talking about real, full-on magic. I promise you won't turn into a toad. This is the magic of art and creativity; the *only* sort of real magic there is.

Ok. Let's look at this.

Creative expression requires an inherent inner talent, which we all have; it comes from the core of our being. A person's talent comes from *who* they are, not *what* they are or what they can do. It's our inspiration, our instinct, our perception, and our vision. These qualities are some of the core requirements in music, dance, acting, filmmaking, or fine art; all crafts where body and soul are the 'tools of the trade'.

To be ready to receive, you need to be in touch with yourself. Honestly!
To be in touch with yourself, you need to *get out of your own way*!
To get out of your own way, you need to trust yourself and stop thinking.
Do not impose *anything* on to yourself or your work as an actor.
Do nothing!
Merely get out of your own way, and trust.
Get out of your head, out of your ego.
To do this, you must connect with your own magic.
To do *this*...read on.

Without this mindset, I believe your acting will be mechanical, cold, and clinical; a paint-by-numbers system, perhaps a technically brilliant performance, but devoid of truth.

But if your work comes from the original, authentic, secret 'you' then there will be — there *can* be — no mistakes. Your true inner spark knows best and is right every single solitary time. Every Time!

We must lay down bedrock and let free our true nature to take the driving seat. We must drive the acting techniques, and not allow these techniques to drive us. Get us out first, before we can even begin to receive actor coaching. If we do this, *then* we will crack it!

Now, as I have said, when I talk about the Magic of Acting, I am not talking about stage trickery or parlour tricks. Neither am I talking, (you will be pleased to know) about pentagrams, goat skulls, and black T-shirts. I am talking about real magic that is as old as the universe. The ancient Greek actors referred to it as 'The Gods descending.'

The stage magicians will tell you, "Ah, but it's not *what* you do, but it is *the way* you do it." Well, they certainly got that right. And this being the case, why not do some real stage magic that will be an authentic *Tour de Force.* How about this:

- Walk onto the stage. Forget the sequined shoes, the mysterious stare, etc.
- Sit at a table. Say nothing; in fact, make no connection with the audience whatsoever. Be aware of them but know this is your private moment to which the audience is not invited.

- Pour some cornflakes into a bowl.
- Pour milk over the cornflakes.
- Sprinkle a little sugar, maybe.
- Eat the cornflakes.
- Stand. Say nothing. *Do not bow*.
- Leave the stage.

What do you reckon?

After all, remember, it's not what you do, but the way that you do it, isn't it?

Imagine Marlon Brando, Jack Nicholson, Leonardo De Caprio, Eli Wallach, Frances McDormand, Anthony Hopkins, or any of the truly great actors past and present walking onto a stage and going through the little scene above.

It would be compelling, truly magical. You would not be able to take your eyes off of them. You would be transfixed, *mesmerized*. These are genuinely creative magicians. Their work is real, and it is powerfully compelling. You could happily watch any of these people walk across a desert.

This is real stage magic, which you can't learn by buying a piece of tomfoolery with a set of instructions from some random guy in a trick

shop, entertaining though it may be to some. There's nothing wrong with that, but not what we're looking for here.

This book then, will I hope, help you to connect with the magic that truly exists within you, which you can then bring to life through your acting. It is all already there. All you have to do is access it.

Disclaimer:

OK, some stage magicians are quite entertaining.

So then, it is my contention that we each have within us an unlimited potential that we can tap into at any time. We have a pre-set ability and a pre-set knowledge that will enable us to do pretty much anything we want to do. All we need do is get out of our own way and work from our special place within: our original authentic selves, our own unique magical, free-from-ego us.

We can all become the actors we want to be if we can only put this aspect of ourselves in the driving seat. Most actors don't. They are stuck in the need to use a system, a technique that will generate a result. They think that engaging with a system will take them to acting brilliance. This is a mistake. We should not work for results. The result will take care of itself when we inject the right intention into the process.

We are all of us already actors anyway, acting regularly in our day-to-day lives. We inhabit various 'versions' of ourselves to fit a given situation. For example, the side of us we show our boss is generally different from the side of us we show our friends, and we are a different 'us' with our partners than we are with our siblings. So we each have many different aspects to 'us', and when we inhabit any one of them we are acting. But there is one particular part of us that is far more radiant than all the rest put together, and it is from this place that as actors we need to work from if we are to become exceptional.

Actors in training learn to employ a methodology, to engage with a system in order to achieve truth in their work.

What 'system' do you need to be real and honest? Why not let the magic of inner truth simply emerge? Most of the 'methodologies' or 'systems' were developed to help actors who for one reason or another couldn't access their own truth. This book, I hope, will help you access that authenticity.

The Magic of Acting then will reveal:

- What is meant by 'The Magic of Acting';
- Why the methodologies are merely clinical, without our own originality;

- How we can access this special place, which most of us have forgotten;
- Why there is no such thing as the 'character';
- How we can develop a sense of place and understand 'where we are' right now, both inside and out;
- ...And how all of this applies to our acting, and much more.

Whichever way you look at it, acting systems are just that: a system to achieve truth.

A System for truth? Why not just be honest?

How can this be so difficult that we need to follow a formula in order to be honest? What we end up with is an approximation of honesty. A passable imitation, sure, but an imitation, nonetheless. We put so much faith in a clinical methodology that we actually believe we have achieved truth.

Truth already exists. It has its own status. It is not created or conjured, nor accessed by the use of 'actory parlour tricks'. Your real truth comes from a deep and exceptional part of you, a 'you' that you probably haven't visited for a long time. It is this 'you' which enables you to access truth anytime, anywhere, and in any situation, every time, easily, and without effort. Look, I am not saying that you are unable to be truthful in life. You are. So why then when it comes to your acting do you need a

system to achieve exactly the same thing? You put your 'actors head' on, and true life goes out of the window. Crazy.

Just be *you*! Unreservedly, unapologetically, and unceasingly! This is not rocket science. You can *only ever* be *you*! There is no one else. Everyone else is taken.

This little book, while aimed at actors, is primarily about the self and how, if we work from a particularly unique aspect of ourselves, we can become exceptional actors — not just good, but *exceptional*! Put your true self at the helm and the systems become so much more real and powerful.

This is not just another 'How to do' acting manual.

It is about 'How to *BE*'.

The truly great actors and actresses were, and are great *despite* any training they may have had. They are great because they knew the secret of **The Magic of Acting**. May the force be with you!

Methodologies

Methodologies seem to me then to be like a hackneyed formula when practiced coldly without preparation of self. When you allow these 'techniques' to drive you, and who you are. You must gain access to the original, magical, authentic *you* and work from this place. Let this aspect of yourself lead the way. **You drive the technique; the technique does not drive you.** I shall repeat this many times throughout this book in different ways. The question we will be exploring is, "Who *IS* this 'you' that we must allow to lead us?" This is very important to understand. Once we dwell with our real selves, we will then, and only then, be ready to 'receive' on a deeper meaningful level that which the acting methodologies seek to teach. Without connection with this 'self' that I speak of, the methodologies will be **empty, clinical, paint-by-numbers systems.** *With* this connection, the methodologies become powerhouses.

"Of course", I hear you say, "You must commit, and engage with the work from the heart, that's just applying yourself". It's 'only' this or 'just' that, you say.

Wrong! It's not *only* or *just* anything. This is something that is so powerful it will change your life. You have to re-connect with that unique self you will have locked away for safekeeping, but have perhaps forgotten where you put it: You are understandably very protective. You need this. Don't

worry, this aspect of you is very strong and very brave. This is your best buddy. Any of this ringing any distant bells? Here's the thing: you do not go and do some course in acting and come out of it a successful working actor with great talent, skill, understanding, ability, and wonderful perception. Acting students, generally, seem to go through the motions as taught (Note that I said 'generally') without a deeper self-awareness. They blindly and slavishly carry out techniques as instructed, thinking that following a formula is all they have to do, making the result sometimes technically sound, but still cold and artificial.

Your work should come directly from you and not from the constraints of some hit and miss system — hit and miss because they are fallible. The thing is, if these techniques were so great in and of *themselves,* then anyone who studied them would become a brilliant actor which quite simply is not the case. Just because you go and do some course in Method acting or the Meisner technique does not guarantee anything. Magic/art does not work when gone through in a mechanical, clinical ABC way. It must be charged with honesty, the right intent, and a truth which should originate from the very soul; **the innermost secret *you*!**

This *must* come first!

It is you that drives the system and not the system that drives you! The methodology does not work the magic; rather the magic makes the

methodology work, and this magic exists within you. But again, *who are you?* Read on, my esoteric adventuring friend.

Change is always challenged. I hear the voice of the little guy that sits on your left shoulder, whispering into your ear. This is your inner critic who wants to keep you where you are; it lies to you. Do not listen. This is superficial mind babble. Feed only the good wolf. The inner critic is on the flip side of your original primordial voice. Good guy, bad guy. Listen only to the good guy. The good guy will not lie.

You have a relationship with your perceptions of the events of your past, which actually have nothing to do with you. These events are just things that happened to you; but they are not *you*. You wrote your own narrative based on these 'events': Your awareness of these events and how they affected you because of how you interpreted them, in turn influenced what you invested in them. Again your perceptions are things that happen to you, but they are not 'You'. We are therefore living a kind of lie based on the outside stuff that happens, and then how we allow that to affect us. We give circumstance too much power. We carry memories around with us that are based on our *'interpretation'* of past events, and then we somehow see all of this as being 'who we are': We carry all of this baggage around through life. We make a life out of it all. We allow 'it' to drive us, when it should be the other way around. We are who we are, but let's try and recognise the difference between the 'real'

us and the baggage our self lies trick us into believing is us. In acting, then, do not let the *desire* to be an actor drive you; rather *you* must drive the creative role. We must put our baggage on a leash. Keep it though—it can be useful in our acting — but do not allow it to 'become' us.

Critic:

OK. That's it! I've had enough of this! I've seen actors in class and in the industry on stage, and on-screen who were most definitely in touch with their 'true inner selves,' as you put it and the emotions they gave in performance were very real. They were totally in the reality of the moment.

Another thing, while we're here! What about Marlon Brando, a famous exponent of 'the Method' as taught by the great Lee Strasberg, and Brando's practice of the technique taught by Stella Adler? What about him and others like him? Are you saying that they are 'cold and clinical'?

Response:

No! Of course I'm not. Brando, as an example, was a fantastic actor. Honest and authentic. I'll tell you this much though: Brando was a tremendous actor *in spite of* his studies with Lee Strasberg or Stella Adler, not *because of* them. Brando had an unusual magic

ingredient. He had a unique thing that no one else in the world has ever had or will ever have. He had Marlon Brando-ness. You too have your own version of this. You have 'Rob-ness' or 'Sascher-ness', 'Peter-ness' or 'Lisa-ness' — just put your own name there.

Brando had developed or brought out and nourished his own true essence; he had connected with his own magic. After that, his studies in acting were a different experience. He was able to engage with what he learned in a much more charged and compelling way. It was not cold and clinical: a superficial form of cause and effect driven by the ego, or some outward, imposed personality. However, if we listen to our inner voice, and we are led by this, then we can embrace the baggage, so that we now hold it all on that leash, and take it all on stage with us. We can be real without assimilating. More instinctual and less procedural.

The actors that you have seen that you are so impressed with, the ones that show 'such truth' are fooling you (Unintentionally) with the brilliant paint-by-the-numbers picture they create. Or, they *are* real because they are one of the few who, like Brando, who understood deep down that which I call 'the magic of acting'. However, if you were to ask them, they probably wouldn't be able

to tell you about it because 'The Tao that can be explained is not the Tao'.

Critic:

Well, if a 'paint-by-numbers' performance, as you describe it, is brilliant, then that's a job well done, isn't it? How does it matter how you arrive at a performance so long as you get there? It's whatever works for you, isn't it? What's the difference?

Response:

The difference screams volumes at you! A piece of creative work is empty if it does not contain within the process this inexplicable magic I'm trying my best to describe. The Art comes first; you can add the technical stuff later if needed. Put a perfectly executed, very accurate, beautifully done paint-by-numbers copy of a Caravaggio next to the real thing. Only one of them has the power to move you to great joy, or to tears. *That* is the difference. It is what the artist invested into the *process* of the creation, the mental injection which came from the original, unsullied authenticity of themselves.

I am trying to do the impossible here. I am attempting to explain that which cannot be explained. To reach out and touch the

unreachable, which is the pain of all artists. As the backdrop to this book is acting, you *will* become a brilliant actor, provided this is not your primary intention, as that would be a return to superficial ego. It would mean your purpose is conditional and therefore not pure which will push you away from your attempt to meet *you*.

Apart from the greats, very few actors, (and by actors I mean both male and female) have harnessed this inner magic. That magic is what makes a great actor, and it's not very hard to bring out. 'An actor's talent lays in who they are, not what they are'. It is a state of being, a mind set. It is an experience of understanding inside, and not an analytical or intellectual process.

Acting is an understanding of self awareness. A deeper secret self awareness.

OK, some of these methodologies are a workable system that will bring an approximate result when the student simply goes through the motions of the process. The result though will not be real, true and honest, because it (The resulting performance), will be manufactured. It will be a result of something we are told to do, in the studio or classroom, in order to arrive at a desired destination instead of simply being there.

That desperately sought-after destination actors strive to arrive at already exists within us. It *is* us. We are already there, and any attempt to grasp at

it through some kind of system will only serve to drive it further away, leaving us with some sort of imitation and a feeling of frustration. I really want to drive these points into your mindset because they are at the core of what I am attempting to say. Let me reiterate and re phrase.

Methodologies teach that if you follow stages A, B, and C, then D will happen. Your acting teacher will tell you that 'sense memory' will affect a result emotion. Your Meisner teacher will ask you to do nothing unless the 'other' person makes you do it. You observe the behavior of the other actor and see how they make you feel. You are looking for something. These are 'steps' that you must take. There is a methodology that you must follow, and it is quite specific.

This can work to a certain extent. It is like a watered-down version of cause-and-effect, and cause-and-effect is behind magic and creativity, but to be *truly effective,* it must be charged with the correct intention, and truth, which can only come from your original essence. There's a beautiful simplicity about it. It is something that happens when you experience the authentic you, and not some superficial version of your egotistical 'actor' personality.

Creativity and art are a kind of magic, and all magic is a creative art. There is no difference between the processes of the two. Magic and Art are the same thing.

Here is the real secret of magic — and trust me, Harry Potter has *nothing* on this- here goes- *everything is magic*, and here is the best bit: *anyone* can do it. It is not special; it is not something that only special magic people can do. We are all magicians. We are all creative. The tricky part, (no pun intended) is realising this.

Now then: Magic changes us inside. We visit and dwell within an inner state, which in turn will affect the outer world because we engage with our world differently due to our magically/creatively altered state. Whether this be the real world, or the real 'imaginary' world of the play/film. We affect a change, causal or not, either inside ourselves or in the outside world.

Can you see the similarities here to what you need to do to achieve powerful acting? Don't worry; by the end of the book, you will know how to connect with all of this. Relax. Baby steps. If we are honest and truthful from deep within ourselves (the doors to which are closed when we resort to artificial 'trickery'), then we will seldom need a toolbox. The tools are fallible; they are not consistent. However, as actors, we are *not* constrained or fallible. Our 'special' place *is* reliable and consistent.

I repeat myself intentionally, because a thing worth saying is worth repeating.

What methodology does it take to look at someone, and simply say "I love you", and mean it?

When you do this, magic happens. In order to create truth in an imaginary situation like acting, you can 'mean it' if you stop obstructing yourself and stop thinking, and don't get bogged down with 'systems'. Just trust in yourself and leave it to your childlike spontaneity. Listen to your inner truth, that inner voice and it will never lie to you. It knows how to do *everything*, and it will work for you every single time. If you have any doubt what so ever, then it is not your original primordial voice. It will be your ego, or superficial self, engaging in mind babble and inane chatter. It will be that little guy on your left shoulder.

In acting, whenever doubts or fears arise, simply return to your natural state of primordial freedom. You will know for sure the genuine thing when it comes, and it wants nothing in return; it is unconditional. Just accept the given circumstances that the writer has given you. No need to 'believe', because if we start to engage with the action of trying to 'believe' in our situation, it means we are trying to do something and will need to resort back to the methodology. You cannot actually be on the ramparts of Elsinore Castle if you are in some gritty little room above a pub in some God-forsaken area of some grim, depressing town. *But*, you can use that reality of where you actually are. Just recognize the truth of where you actually are in reality, and then no belief is required as it

becomes sure fire knowledge. Now overlay this reality onto the fiction, bringing truth to the imaginary situation. The audience cannot read your mind. They don't know that you are acknowledging the space you are actually in, and not some imaginary space. All they see is truth emitting from you, and they can pick up on the emotion you are feeling which again comes from your inner spark and the script. Don't push it. Allow it.

You can have no more ability to *actually be* somewhere else than you can *actually become* somebody else. You can, however, *allow* it to be, because if it exists in our minds, then it exists because the mind is real, and the imagination affects the real world. Where does anything exist if not in our understanding of it? This is not merely believing in something; this is knowing it is real because we have *made it real* by accepting the reality of our situation.

Critic:

But this is just working on the script; it's just standard character work.

Response:

There you go again! This is not 'just' anything! It is so very much more because of the place it is coming from. This is not a technical process. If you think it's 'just' anything, then this is the window dressing of your egotistical mind babble. It is the oil rag talking.

Why not listen to the engine driver within? This is not some flouncy luvvie actor thing here. This is much more important.

Let's take a brief look at a couple of these methodologies before we get to the **important stuff**.

Method Acting:

Mark this, dear reader:

It is not my intention to belittle method acting. I believe method acting to be a very effective set of tools to keep in your tool box should you ever need them to aid the rehearsal process. But, they are just that: tools to be used in the acting gym. You would not however take these tools on stage with you, just like the boxer would not take the weights into the ring with him. The workout stays in the gym, and you go onstage muscle bound.

Some of the best actors in the world have studied the method. Brando was a great actor in spite of his training. He had 'Brando-ness' and it was this that drove his acting and it was this that kept his toolbox in order. He might have used it on occasion, but wouldn't have needed it often because he had that which we all have. The game is to unlock it.

Method acting is a system of 'how to act' developed by Lee Strasberg, which sprang from another system created by Konstantin Stanislavski, who was an actor/director with the Moscow Arts Theatre. During his

unbelievably long rehearsal periods, sometimes lasting up to two years, Stanislavski noticed that his actors were having difficulty accessing truth on cue, so he developed a system to enable actors to 'create' truth. Strasberg then took this system and tweaked it all around a bit, coming up with his own version which we know as The Method.

The Method teaches us to take from the real events of our own lives and to recall these events effectively for whatever role we are playing.

Because they are real-life events, and personal to us, the memory will be real and emotionally resonant. We raise these 'emotional' memories by recalling the sensory experience that accompanied the event at the time. So, in order to achieve a certain emotion or state of mind for dramatic purposes, we must use a formula as prescribed by the practice of this methodology.

One way we are taught to achieve this is a process called 'sense memory'. Here's how it works.

We sit in a chair and close our eyes. We now breathe in, and then we breathe out. Repeat this process. We then take ourselves through a relaxation exercise. All good; never hurts to relax, right? The relaxation exercise as used in the Method, as I have experienced it, is a series of movements while at the same time emitting a continuous 'ahhh' sound.

When we are 'relaxed' both physically and mentally, we begin our sense memory exercise.

There are many different sense memory exercises, but normally the one which most people begin with is called 'the coffee cup'. The actor recalls in his/her memory, the sensory experience of drinking a cup of coffee. This can also be tea or any other hot drink. The theory being that it is the sensory recall that will trigger an emotion. What kind of aroma does the coffee have? (The sense of Smell). What does the coffee look like? (The sense of sight). What does the coffee taste like? (The sense of taste). What does sipping and swallowing the coffee sound like? (the sense of sound) finally, how does holding the coffee cup feel like in your hand? (the sense of touch) This must all be done in the minutest detail, very explicit, and very exact. You should now feel something. Maybe nothing big, perhaps something small and subtle, but something. The idea being that we can create a feeling or emotion through sensory recall, which we can then repeat when needed. It can be generated. Some other sense memory exercises which all go through the same format are shaving, applying make-up, and taking a hot bath or shower, all of which are designed to exercise the sensory recall muscles in order to 'well up' a feeling.

There is, of course, a great deal more to method acting than this, but the above should give a flavour of things.

Meisner:

As with the Method, I am most certainly not belittling Miesner. It is a system favoured by lots of actors the world over. Designed by Sanford Meisner, it was another system based on Stanislavsky's Method. Miesner taught his technique at the Neighbourhood Playhouse in New York. Curiously, in my experience, Meisner actors tend to criticise the Method. I, for one, think they both belong in the same toolbox, even though they appear to be opposing systems. With the Method, you take from your own life and work from the inside. With Meisner, it is all about 'the *other* person'. You put all of your attention on the other person, and you do nothing unless the other person causes you to do it impulsively. The main Meisner exercise, and the main thing in all Miesner classes, is 'The Repetition Exercise'.

Here's how this one works:

Two chairs, two people. They sit facing each other. One of them Person A begins the exercise by voicing a simple observation about person B. This can be something like, 'You're wearing a green shirt', or 'You have red hair', or 'You're smiling'. The person B (the 'other') then simply repeats what they hear, so will say 'You're wearing a green shirt' or whatever was said to them, even though person A is not the one wearing a green shirt.

The pair repeat the line, back and forth, until the class facilitator stops the exercise — which can go on for up to half an hour.

Next, there is a slight change: the repetition is personalised. Instead of person B simply repeating exactly what they heard, they speak it in first-person. For example, if person A says 'You have red hair', person B will now say, '*I* have red hair'. 'You have red hair'-'I have red hair' and so on.

Next comes the stage of repetition change. So person A starts with, let's say, 'You're Smiling' (assuming person B *is* indeed smiling). The response from person B will be, 'I'm smiling', so the person B personalises the response, and so it goes, until one of them feels an impulse to change the repetition based on what the other person triggers them to say. So, if one of them has an itch and they scratch their nose, for example, the observer might now say, 'You scratched your nose'. And now the response will change to 'I scratched my nose', and so this goes until the next change , based on the next thing one of the players observe about the other.

The above exercise is practiced extensively and consistently. There are, of course, other aspects to Meisner, but this is not a book on Miesner. This is only a quick overview. There are plenty of books available should you wish to look further into it.

Stella Adler:

Stella Adler differed from Strasberg in that she couldn't come to terms with the idea of emotional memory. She reportedly said that drawing on the memory of some past traumatic event in order to create an emotional response was "sick and schizophrenic, and if that is acting then I don't want to do it".

Adler did indeed work with the senses, but not with sense memory. Instead, she worked with sense *imagination*, so that the sense being imagined was not attached to a particular personal memory. Practitioners imagine both the sensory and the emotional experiences using the given circumstances in the script. Adler also believed in extensive study. For instance, if you role is that of a lawyer, then you should make an extensive study of the law. This way, you are not lying. We all have heard about actors who do this.

Neither Stanislavski nor Adler believed that actors already have installed within them that which is required to play any role within reason. They believed actors had to develop the skill through study and research. To make choices about the 'outer' character. Adler said actors should study the circumstances of the text to discover things like how the character walks and talks, and what their body language says, etc. She always used to say, "Don't be boring", and "In your choices lies your talent".

So, imagination, study, and simulation; Stella Adler's method in a nutshell.

Intention:

While I believe it is extremely beneficial to work only on the process without thought of a result — thinking about results will only serve to get in our way and stifle us — we should still have an intention, that intention being to live truthfully and honestly within the given circumstances of the piece as written. As that truth can only come from you, your intention will be to allow that truth to surface from your inner authenticity. Simply open up the channels from the soul of your being.

This is the magic of declaration. Trust your mind. Declare it to be so, and it will be. It will be because you say so. You give it permission to be. If the scene requires anger, for example, then simply allow anger to surface from the core of your being. You know how anger feels, don't you? You've been angry before in your life haven't you? No need to generate it with the use of a system. Just feel angry; allow the script and where you are within the scene to call it up from your core. You have overlaid your own inner truth onto the fiction of the script thus making the script real. Declare it to be, and it will be. No need to believe; belief is not required where truth exists. The truth does not require your belief. When in life you feel angry, you do not *believe* you are angry — you just *are!*

When Canaletto painted, he painted from his soul. His inner beauty did the painting. His magical madness applied the paint onto canvas. Yes, he held the brushes, and the paint was on the brushes, but it was his very soul that applied the paint. The brushes were merely an extension of his will, a bit like how a wizard's magic wand is an extension of his will.

The paint-by-numbers artist paints only with brushes. *He relies on his tools.* He allows the tools to drive him towards a result. Can you see the analogy I'm making here? You can see how it makes perfect sense. Paint from the soul, and you engage with the tools in a totally different way. Act from the soul. Emotion comes from you, and not from an applied technique. Engage with your acting in the same way.

Critic:

Yes, this is all very well, but methods and systems are doorways to the inner self; they are the craft we must learn in order to get to our inner truth.

Response:

The very fact that we are applying a methodology means we are doing something when, actually, we need to do nothing. Our true power is actually hampered, and held back by the interference of these systems. The systems get in the way because we are imposing something. Truth is already there. It is not created; it *is*

the creator. These systems are an unnecessary nuisance that just confuse things. Problems are actually created, and not solved.

It is *all*, in fact, the opposite way around. Systems of acting do not help us get to our inner truth. Rather, once we have connected with who we are, then this will inform our studies of systems. The systems are a toolbox, only to be used if needed.

Critic:

So do we need to train then? What about Drama School? Are you saying Drama School is a waste of time?

Response:

No, I'm not saying that. Going to an excellent Drama School is a great opportunity to practice the art of acting without the need to worry about the process of surviving in the industry.

However, there are some drama schools in the UK, and a few in the USA, whose mission, it seems, is to 'deconstruct' the student. They then manipulate, rearrange, and reconstruct, so students come off of that particular school's conveyer belt all much the same. Clones — They have been manufactured, manipulated, molded into that drama school's idea of what it thinks an actor is. They want you to be a blank sheet having worked on students in an almost psychological way to clear him/her of

past conditioning, working to create some kind of golem or artificial person fashioned into a vessel for phony characters to inhabit. No wonder so many actors have mental health and drug issues. Three years of trauma and £30,000 later, students leave these schools unable to deliver a line in a truthful way.

Now, I'm not saying all drama schools are like this- they are not. Some are most excellent and they lead the world in actor training. If the student has prepared herself to receive the training and she approaches the study from the right place within, then success is more or less assured. But to those other schools, I say this: I believe that as an actor you should simply be 'you'. No need for manipulative reconstruction; just be you, along with all of your wonderful beautiful flaws, foibles, and faults, and conditioning! Embrace your baggage and take it all with you on stage, just like a real person. How dare these schools say you are not good enough just the way you are? How *dare* they want to turn you into something they want, into something that will fit onto their conveyer belt?

At the start of this book I talked about a piece of Taoist philosophy that says 'The Tao that can be explained is not the Tao'. Taoism also says 'Look for nothing, and see everything'. You may have heard the expression which illustrates this, 'You can't see the wood for the trees'. Same thing. Another piece of Taoism says 'Do nothing, achieve everything'. Things have a way of working themselves out and coming good.

Just be the wonderfully flawed you that you are.

There's a crack in everything; that's how the light gets in."

— *Leonard Cohen.*

Acting is a state of mind, an understanding of self-awareness. How, then, do we connect with the authentic magical 'you' I'm going on about so that you can become the actor that you want to be? Patience is a virtue. We will get to it, I promise, but no jumping forward now! Before that, let's take a little look at the 'Character'.

The Character

Are you sitting down? Prepare yourself, because I am about to say something that may contradict everything you thought you knew about preparing for a role. Here goes then... :

<div align="center">

THERE IS NO SUCH A THING AS THE CHARACTER.

THE CHARACTER DOES NOT EXIST.

</div>

Phew! There, I said it.

Know this: It is not possible to actually be something you are not. You can only ever be you. And that is plenty good enough. Every part you will ever play will be a 'self-portrait' — just as every portrait painting that any artist ever paints is a self-portrait because it is they who are painting. It is always a mirror of themselves and how they perceive the subject of their attention to be.

Critic:

But surely the artist, like the actor, captures the essence of the subject being painted or dramatically portrayed.

Response:

The artist or actor captures that which is inside his/herself because the artist is seeing the subject through his/her own perception,

through their own 'lenses' on life. What gets onto the canvas, or the stage, or onto film is an aspect of us — a mirror of ourselves. We can only be our wonderful selves.

It is simply not possible to be something you are not!

Fortunately, we are many things. We each have within us countless versions of us, and we all have within us the 12 main archetypes which in turn have innumerable subdivisions. Still, I don't want you to get bogged down intellectualising about archetypes; they are there anyway whether you understand them or not. Just be aware that you have oodles of versions of *you*. We will take a brief look at archetypes shortly.

(For an in-depth study of archetypes, I suggest you read Carl Jung as a starter.)

"There is no such thing as the character!"

Well, whaddya gotta say 'bout that, then? (He asks, in the style of some phoney character)

"Have you gone stark raving bonkers?" I hear you think, "Surely that's the whole thing about acting, isn't it? As an actor, you play a character, Don't you?"

Nope! This just isn't possible. Who is this character you think you have to pretend to be? The character exists only as words on a page that the

author has written. Those words are just a guide. You now have to find some empathy with that text.

You can't actually become something you are not! You can pretend, yes; you can fake it, sure, but you simply can't actually morph into something else so that you are no longer *you*, but something completely different. Unless of course you are a lycanthrope. But even then, the wolf or some other cryptozooalogical mythical beast that you become on the full moon, when the wolfbane blooms, is even then only there because it is a part of your hidden inner being. In a sense as actors, we are all shape shifters, so to speak. Look at Robert Louis Stevenson's *The Strange Case of Dr Jekyll and Mr. Hyde*. Here there are two sides of the one coin where one man shifts from one being to another but both are the same man. We are what we are and always have been, and evermore shall be so. There *is no character*; the character *is you*.

That's a *huge* let-off, isn't it? Never again will you have to do all that hard work long into the night searching for some nonexistent character, like the blind man in the dark room looking for the black cat that isn't there! Some actors manage to find it! But all they've found is a comfortable way to pretend. There is no character to find. The Character is already here! *Hello*!

We each have within us many aspects of who we are. We have a shed load of different sides to US. Some of these 'versions' of us are buried deep; others are to the forefront of our daily waking hours. We have a normal state of being — a homepage of personality, if you will. In acting, *this* is our starting point. This place is real and true. All of your acting from this very moment on must come from this place. We start with who *you* are, and not some made-up, put-together lie.

Believe me; *you* are far more interesting just as you are than any made up false piece of pretence. The truth is always far more powerful than a lie. As actors, we bring truth to fiction as we overlay the fictions of the script with the truth of *us*!

As actors, we *are* the character. The character outside of 'us' simply does not exist. We merely have to be ourselves, unreservedly, unapologetically, and without censorship. Open, and primal as we let emotions run free. (Couldn't be easier, eh?)

BE YOU! But that aspect of you that most closely fits what the writer has written. It *has* to be you. You don't need to try to be somebody else. We are, each of us, all things, anyway. I have probably repeated this enough times now to have driven my point home.

The Archetypes

The archetypes are a kind of repeated concept that crops up everywhere. A sort of pattern of similarity. The Greek myth archetype is found in the stories of the heroes and the Gods, whereby the protagonist meets the antagonist, conflict occurs, and the hero protagonist wins the day. This is the archetypical Greek story seen in children's nursery rhymes (like *Little Red Riding Hood*) and in Hollywood movies (like *Superman*). We see the reoccurring theme appear also in architecture. For example, the Chrysler Building in New York is archetypically Art Deco. Human beings all have reoccurring character/personality archetypes, as well.

So, what about these other versions of us, then? What about the hidden, or not so hidden, sides to us? Well, let's go right back for a moment to where theatre and acting as we know it today began: ancient Greece.

The ancient Greeks had their 'Archetypes'. We each have all of these as part of our personality. We are all of these things:

- The Warrior
- The Teacher
- The Parent
- The Lover
- The Child
- The Artist (sometimes called the Magician)

- The Fool
- The Sage
- The Carer
- The Rebel
- The Explorer
- The Ruler

There are loads more, sometimes called different things, but these are a few of the main types that exist as a part of every one of us. They will also all exist within each other, but exist they *do* as components of us.

Carl Gustav Jung had this to say about archetypes:

'The concept of the archetype is derived from the repeated observation that, for instance, the myths and fairy tales of world literature contain definite motifs which crop up everywhere. We meet these same motifs in the fantasies, dreams, deliria, and delusions of individuals living today. These typical images and associations are what I call archetypical ideas. The more vivid they are, the more they will be coloured by particularly strong feeling tones. They impress, influence, and fascinate us. They have their origin in the archetype, which in itself is an irrepresentable, unconscious, pre-existent form that seems to be part of the inherited structure of the psyche and can therefore manifest itself spontaneously anywhere at any time'.

(*The Structure and Dynamics of the Psyche*, coll. works, vol 8, p. 213.)

"...manifest spontaneously anywhere and at any time," Ummmm!

Interesting. Could this have anything to do with acting, I wonder?

You might like to try just sitting quietly and giving some thought to you. *Who am I? Where am I right now, at this moment?* Connect with how you feel, no matter how slight or subtle. Ask yourself, "How do I 'feel' right now"? Do you feel strong, like the warrior? Do you feel vulnerable, like a child? Whichever one you 'feel' then this is your starting point. You are 'being' with your own truthful state. Very good. Now, how is the state you are now in going to deal with the requirements of the script? I don't know. Only your child, or warrior knows this, but however they do it will be real, and right because it is honest and true. Just let how you feel, no matter how subtle or strong, simply be with you. Do not try to grasp it, and do not invest in it: neither should you deny it: just allow it to be there, and notice it.

One of the finest actors in the world today, in the opinion of many, is Meryl Streep. She has said that "Empathy is at the heart of the actor's art". She's right. Empathy is an essential component in of the playing of a role truthfully and honestly. We must have an empathy with what we are going through in the world of the script. Not what some character is going through; as we have said, there are no characters. It is what we, as real

human beings, are going through. This does not have to be the big deal experience. If we have just been told that we have won £20 million on the lottery, or that our entire family have been killed, then who is to say how we would react. There are no definitive rules. However we feel at the time will determine how the news affects us, and how we react. You cannot plan an emotion. It has to be spontaneous.

The writer may have written that we have just lost our job, our home, and our marriage. Empathy with this will raise a particular aspect of us. We've all had a bit of bad luck. Right? It will 'tickle' one of our archetypes depending on how losing something we value would affect us. It might wake up the Warrior within as we become determined to get through the setback and find another job and a new life. Whatever it is, it will bring a feeling, and this 'feeling' or 'archetype' will have all the other archetypes present in the background. Empathy will wake up the archetypes. Don't think about this; don't *do* anything. Just empathise and imagine.

In acting, there is an aspect of you that will fit perfectly into the role you are playing. Just go within to the land of archetypes and invite whichever one fits to come out and dance. Connect with how that part of you feels. This is no methodology; just go inside, be still, and think about yourself as the child, or the teacher, or the parent — it doesn't matter — whichever one fits the role you are playing. In truth, you can start with any one of them because even if you are playing a violent murderer, this character

will have within them all of the other types as well. It's just that the murderer is at the forefront. We are multi-faceted, and all of our inner aspects are waiting for us to call upon them to handle whatever the situation. You would not send the fool to do the warrior's job unless you are in a comedy movie, but the fool, of course, also has a warrior within them. In life, we call on these different sides of us to fit the moment every day. It is the same in acting.

Now then:

What part of you is in charge of all the archetypes? I believe it is a separate aspect of you that is stronger and more beautiful than the rest combined. It is your original sparkle! It is what the ancient Greeks called the **'Daemon'.** Believed to be a sort of guardian angel that guided you through life. It was the name the Greeks gave to that instinctive voice within.

Everyone is an actor. Acting is a fundamental part of what we are. We need it. From prehistoric times, when early man draped himself in animal skins to disguise himself when hunting with a handmade flint spear, he was taking on the role of the animal in order to fool his prey. He was acting. As children, we give voices to our toys and pets. Who hasn't given a silly voice to a pet dog or cat? It *can't* just be me. Here we are again, acting.

"Does my bum look big in this"? "No! Of course not," we lie, "You look great". Again, we are acting.

So, if you want to embark on a career in this totally bonkers world, then you have a great start already; you have been acting all your life. Life acting, though — if we might call it that — is slightly different from a career as a professional actor. As a professional actor, you will need to be able to 'turn it on' on cue. You will need to be able to instantly access any emotional state that you have sitting behind your belt of life experience.

Children, although their life experience is limited, are very good at this. We can learn from very young children. They are brilliant actors. They are able to be totally in the moment, and they have no problem being 100% honest. Watch very young relatives as they play their games. They are totally immersed in the game: for them, it is real. They are focused, and the whole thing is a private performance they are playing out with each other. They are aware of the grown-ups in the room, but the grown-ups are not invited to take part in this game. Without realising it, they are practicing a very valuable exercise in acting. This is a private gathering. They are behaving as if unobserved. Very good! Your next step in becoming an actor, then, is to be clear in your mind about *why* you want to be an actor. All successful endeavours will have a clear and integral intent behind them.

Do you want to be an actor because you want to find fame and fortune in some TV soap? Or, do you want to be an actor because you yearn to do some good work that you can communicate to others through the storytelling process while, at the same time, travelling through a multi-layered territory of self-discovery? I'll leave it to you to decide which one is your optimum way forward.

Next thing. As an actor you must constantly tune your instrument: your voice, and your body. A maestro violinist never stops practicing.

Are you in your right mind?

It has been a long held belief that there are two sides to the brain, the left brain and the right brain. We each of us use both sides of the brain, but you are either predominantly a left brainer or a right brainer. The left side of the brain is concerned with logic and practicalities, while the right side of the brain is more concerned with the abstract and creativity. The language of the left brain is different to the language of the right brain it seems. To try to explain the nature of art or the abstract with logic would I suggest be difficult and vice versa. The logical brain is extremely useful of course, and even essential in life, but perhaps not a great deal of use in creative endeavours. So as actors we need to use our right sided thinking to free ourselves from over analytical thought. Now this is not a

psychology book on left/right brain thinking, but here are a couple of tips that might awaken right brain activity.

Daydream-Let your thoughts run free, drifting where ever they take you, or think about your wishes, and the things that you would do in a perfect world.

Notice Colour - Every day, we see the most vibrant beautiful colour all around, but rarely actually notice and truly appreciate it. Just take a moment to notice the colour that is all around.

Be spontaneous- Do things all of a sudden because you want to. Behave instinctively: let the child in you lose, and break into a skip, or do a little dance, or express a thought or emotion without censorship.

Exercise the imagination. Fantasize. Allow your mind to drift, imagining what it would be like to have lived in a different time. Go into detail.

Just a couple of things to be going on with. Have fun, but of course be mindful of the feelings of others when speaking out.

So:

1. Acquaint yourself once again with the magic of childhood.
2. Be clear about your intentions.
3. Be aware of where you are both geographically and inside yourself. (See next chapter)

4. Stay in touch with yourself. Work with the different aspects of yourself, but let your original, playful child take the helm.

Any intellectualising about a role you are playing will kill it. Don't think, just be.

A great classical actress- Glenda Jackson, once said:

"A technique for discovery can take the place of discovery"

Psychogeography

Psychogeography: A magical sense of place.

As actors, we work not only with our bodies and voice but also with our imaginations and our emotions. We must connect with where we are physically and geographically within the story we are telling on film or on stage. We must be aware of a sense of place and how we feel in this place. A lonely night in prison feels markedly different from a sunny day at the beach. This will inform the way we engage with people. If the scene is set in your own home, then you should know that set as if it were actually your own home. So, develop a sense of place.

There is an avant-garde pursuit called 'Psychogeography' — which has nothing whatever to do with acting (or has it?) — That you could, for fun, look at here. It deals with developing a sense of place, using the imagination, and noticing how places affect us emotionally.

Curious?

It is picking up on the resonance and the residue of a geographical location — the *genius loci*, or spirit of a place, which is engrained in the architecture and sown into the landscape — and then seeing through the eyes of those who have gone before. In this way, we feel what *they* felt, not just in the imagination, but actually picking up on the resonant 'vibe'

of the past. **I'm sure you can see how useful this will be to actors**. That apart, it is also a fascinatingly fun way to spend a few hours.

When I watch an old film, look at old photographs, or go to certain locations, I find I can resonate with the past. I am actually there, and I understand the *genius loci* of that time. It is in my very being, and I *know* that I am not wrong. I am as a time traveller. Hone in. Invest, and it will affect an inner change.

So in acting, we must resonate with the time and place psychogeographically.

Psychogeography is a pursuit, whether practised physically or from an armchair, that people have indulged in since time immemorial. But it has only in recent times arrived in the general consciousness as a labelled and formulated practice.

The term can be traced back to the Paris of the 1950s, to the avant-garde art movements of the 'Lettrist' and 'Situationist' political groups.

A founding father, Guy Debord, defined the term psychogeography as:

The study of the specific effects of the geographical environment, consciously organised or not, on the emotions and behaviour of individuals.

Useful in acting?

Well, when we are emotionally affected by our environment, as we all are in some small way, then this will in turn inform how we engage with the world.

Can a more precise meaning be given though to this ambiguous pursuit? It could be said to encompass ghost hunting (Not only in the form of phantoms, but also the search for a city of disappearances, the things, buildings and people that are no longer there), cryptozoology, and anything else that forms the *hidden city*, factually or otherwise. It is about having empathy with the landscape.

We start by taking the map of a town or city. Psychogeography is mostly viewed as urban, but I personally would also see it as being rural. We draw an outline on the map; circular, triangular, square — it doesn't matter, and then we go out and walk the outlined area, taking note along the way of the 'signposts' etched onto the landscape: street names, graffiti, a cracked windowpane, etc. What could these things tell us about where we are? What story do they tell? What repetition can we find? What connections can we make? Factual or fictional.

We record our thoughts and feelings along the way, either on film or in writing. We look for clues to the unwritten history of the place, and we inject our own fictions formed from our own imagination onto the picture.

The purpose of this ambiguous pursuit is to develop a sense of place. We seek to gain understanding of the environment and notice how we are affected emotionally by where we are geographically.

It is feeling the emotional emanations of a location and resonating with a location's past — feeling its ghosts, fictional, real, or architectural. It is looking for connections and coincidences, and it is reading the signs sketched into the urban landscape.

Why is it that certain places have a 'bad vibe', while other locations are positive and attract creativity? This being constant — an urban slum as against the South Bank of Paris.

Psychogeography is the pursuit of the urban shaman. Author and Urban Shaman, Iain Sinclair (*Downriver*; *Lights out for the Territory*; *London: City of Disappearances*; *Whitechapel, Scarlet Tracings*), has crowned William Blake 'The Godfather of psychogeography'. Blake, a great London walker, said of London, "My streets are my ideas of imagination".

Blake wrote of his own real London but magically charged his work with his 'visionary experience' of the city, overlaying the harsh grittiness of eighteenth-century London with the London of the mind — *his* mind.

The fields of Islington to Marylebone,
To Primrose Hill and Saint John's Wood,

Were builded over with pillars of gold,
And there Jerusalem's pillars stood.

There is a literary tradition connected with the practice of psychogeography. In Robert Louis Stevenson's allegorical tale, *The Strange Case of Dr Jekyll and Mr. Hyde*, the author doesn't just show us the two sides of man's nature; our light side, and our darker, or shadow side, but he shows us the two sides of the city.

We see the wealth and opulence of the West End juxtaposed with the despair and squalor of the East End. In a psychogeographical sense, I believe that Stevenson was suggesting that where we are geographically: and where we spend our time drives our mood, and thus, our character.

De Quincey's drug-fuelled musings as recorded in *Confessions of an English Opium-Eater*, show London from a somewhat lateral mindset.

Arthur Machen seems to create his own territory which he superimposes onto the map of London, creating a kind of dreamscape which has similarities to the real London, but where everything is slightly off kilter, a tad to the left of reality.

In his work, *The London Adventure or The Art of Wandering*, Machen writes:

So, here was the notion. What about a tale of a man who "lost his way"; who became so entangled in some maze of imagination and speculation that the common, material ways of the world became of no significance to him?

We must develop an awareness of place, be that place physical, emotional, or fictional. In so doing, we adopt a mindset where the past shakes hands with the present, and where we build a bridge connecting the world of reality with that of the imagination, creating another world where it all gets wonderfully mixed up — a place of the mind made real by the landscape of the city.

For me, psychogeography is also about ferreting out the psychology of the urban landscape, looking for the outward signs of a geographical personality, timelines merging fact and fiction.

During one of my own outings of aimless wandering, and observant wondering, I arrived at an old haunt of mine. The Serpentine Bridge in London which separates Hyde Park (Visited sometimes I shouldn't wonder, by the enigmatic Mr Hyde himself, skulking around in the undergrowth) and Kensington Gardens. The Serpentine is a man-made lake on land previously owned by the monks of Westminster Abbey until 1536, when, during the dissolution of the Monasteries, Henry the Eighth seized the land and used the area for hunting boar, wolves, deer, and

anything else for sport. All of this was on my mind as I walked through the tunnel on the right side of the bridge facing Hyde Park with Kensington Gardens behind you. It was night, and no one was around. I always find night walking more informative than daytime wandering.

Angels whisper to a man who walks alone.

As I entered, looking to the end of the tunnel, I could see the water through the exit at the end which was illuminated by the moon. My footsteps eerily echoed around the walls of this peripheral place, adding to the atmosphere. I looked at the arched brickwork and considered for a while the builders and masons of this London familiar: What was it like to be them? I stopped mid-tunnel and breathed in the resonance of past pedestrians. What had happened here?

I connected with the spirit of the place. This sort of thing comes easily to me, having been born a 'sensitive' and having embraced and practiced this since childhood. I was transported back to the 1920s. Nothing scary or disturbing as picking up on the resonance of a place can sometimes be, but rather a joyful and content feeling. I saw in my mind the ghosts of two happy and secretive lovers, clean-cut, I would say middle class, and surely members of that group of 1920s youth who became known as 'the gay young things' ('gay', having quite a different meaning then). The detail in which I saw them was intricate — the pastel colours of the clothes, the

stocking seams. On this night, for those two alone, a nightingale sang in Berkeley Square. I continued to the tunnel's exit, affording the lovers some privacy. As I strolled by the shores of the lake, the associations that now pervaded my thoughts brought my own childhood back to me.

I saw myself as a child sailing my toy boat (though I cannot recall ever doing so on this particular water) and I saw the long neck and back humps of a great lake kelpie surfacing on the midnight water, silent and graceful, a notion born in a lighthearted Brit flick of the 1960s entitled *What a Whopper*, in which a group of British comedy actors of the day embark on a caper to scam the press with a photograph of a fake Serpentine lake monster.

Psychogeographically at least, now that this exists in the world of film, there will always be this created beast in Hyde Park projected from our own minds. Not unlike the 'Beastie' of Loch Ness. The latter, though, has such a firm place in our collective psyche that it now leaves footprints. Its Serpentine cousin, that night, fair scared the wits out of the crew manning my toy boat.

I looked back towards the tunnel, my attention drawn by the sound of stifled laughter. To my surprise and amusement, under the arch stood a pair of lovers in actual physical reality. Two modern-day retro punks; or, I assumed they were retro, and that I hadn't passed through another time

portal to the early 1970s. A swan skimmed the surface of the lake, and I am sure that the nightingale once again sang in Berkeley Square, though probably some punky song of aggressive anarchy.

On another occasion, I was walking in London's East end. I wanted to see if I could find some resonance from the past, the residue from a bygone time engrained within the fiber of the architecture. I wanted to summon a few ghosts.

It was late October, and as I walked along the Whitechapel Road towards the city in the cool of an autumn evening, I passed the huge Victorian structure that is The Royal London Hospital with its helicopter landing pad on the roof. The hospital's museum is the resting place for the remains of one Joseph Merrick who, during his short-lived show business career, was billed as the 'Elephant Man'. Across the road at number 259, now an Indian sari shop, is the house where showman Tom Norman first exhibited Joseph back in the 1880s for the cruel delight of nighttime revelers. In the window of this shop was a poster advertising the imminent arrival of a visiting circus to a nearby park. The poster depicted an artist's impression of an elephant standing on a small pedestal.

One block along, I noticed a discarded milkshake that had spilled out over the pavement, the spillage suggesting the shape of a gun. Just a coincidence then surely that the name of the street of the right hand turn

just around the corner was Vallance Road, where the feared Kray twins lived with their mother and from where they ran their crime empire in the 1960s. The milkshake must have been a raspberry flavour, as the colour was a blood red. A police car sped by sounding its siren. "Evening all".

I was looking for connections — coincidences. If we can do this, then we can work in harmony psychologically with the places in which we spend our time, thus bringing about outer causal change but more importantly — inner spiritual understanding, this latter development being the duty of every magician. In short, psychogeographical practice is magical ritual.

I have only been able to give a basic introduction to this fascinating subject here. For further reading, I would suggest writers such as Peter Ackroyd, Iain Sinclair and Arthur Machen. You might also like to try *The Old Straight Track* by Alfred Watkins.

The Situationists

The situationists, one could say, gave birth to modern psychogeography back in the early 1960s. Influenced by surrealism, they were a band of avant-garde intellectuals concerned with transforming the urban landscape by injecting art and culture into everyday life, making creativity the bedrock of the public mindset and social mood.

They opposed the idea of work, believing that creativity was stifled under capitalism. They wanted to blur the line between producers of art and consumers.

The Inner Self

Alright then. Let's get down to it.

This infinite potential, this special 'us' I speak of: what is it then? Well, it is an all-knowing aspect of ourselves. It's never wrong; in any situation, we only have to listen and trust. Of course, it takes a little practice to distinguish it from general mind chatter.

Known by the ancient Greeks as 'The daemon' (meaning 'inner voice', and not to be confused with 'demon'), it is the architect of our being and our personalities. It is our sensory awareness, our instinct, — our guardian angel, if you will.

Because we experience the world through our senses and through our authentic personalities as opposed to our superficial egos then there can be no mistakes if we allow the daemon to lead the way. We only have to stop obstructing ourselves. Just simply take a step back.

It is our link to the divine and is unconditional: It is our best friend, and will never let us down, and he or she is waiting for you: allow me now to introduce you to your guardian angel; your inner voice.

So where does all this come from? This 'other' us?

The origins lay in the primordial unsullied mind, free from parental and educational indoctrination. Your guardian spirit has no baggage. It is the un-carved block of the Taoists, that which has the sculpture already within it, waiting for the artist to reveal. It is already there, perfectly formed. It speaks to us in different ways: an idea which seems to come to us from nowhere, a feeling, an inner thought, an instinctive flash of light, a revelation. This has existed since the dawn of time.

Here the territory transcends beginning: No language: no word that can speak itself into being: here exists only the *potential* for the word, created by the very nature of its own non-existence. And this 'potential', or the '*idea*' of the word: of a *'something'* spoke *itself* into being. And a beginning was born, and in the beginning was the word. And the word gave birth to its own single existence, and thus the single number was born, creating duality: The word, and the number: these existed within the now occupied territory, giving rise to a dimensional trinity.(Don't worry, I am not about to embark on a religious rant). Serpentine strands of mathematical DNA emanate from this primordial soup:

This may have been Dante's vision: this lump of molten rock with its colossal fires, and acid rain feeding the flames, and its white hot gases: the entire caboodle spinning at incredible speed: a small Catherine wheel in the greatest firework display, ever!

This is the realm of demi gods, and Angels: born of the divine nothingness. The essence that exists within everything. It is our thinking, our feeling, our sensory organism, our higher self; it is the spirit that protects us, making it impossible for the fool to undo himself beyond all redemption. You just have to listen!

It will never let us down. Since we experience the world through our senses and our *real* personalities, there can be no mistakes if we allow this side of us to sit in the driving seat. We only have to get out of our own way.

This inner spirit is the author of our creativity: The driver of the machine: The inner force: the architect of our magic: Our artistic inspiration:

What is Art and creativity if not magic?

Magic is THE art!

Skip forward in time a few million years. A minute movement of the imagination.

We stop at the third piece of celestial space debris closest to our Sun, Planet Earth. We descend on to a small island with rivers, and streams, and lush green vegetation, with fish of every colour in the surrounding seas and birds of every shape and hue soaring freely through the sweet-

smelling air. This is the land of Albion, where on this land walk the beasts of the forest, and the open grasslands. And they are beautiful!

Let us explore this land, then.

> This royal throne of kings, this scepter'd isle,
> This earth of majesty, this seat of Mars,
> This other Eden, demi-paradise;
> This fortress built by Nature for herself,
> Against infection and the hand of war,
> This happy breed of men, this little world,
> This precious stone set in the silver sea,
> Which serves it in the office of a wall,
> Or as a moat defensive to a house,
> Against the envy of less happier lands;
> This blessed plot, this earth, this realm, this England.

(Richard II, Act II, Scene 1. William Shakespeare)

Our imaginations fly and we enter the space that you occupy in this instant, as you're reading this book right now, *where ever* that it is you might be on this planet, and we now arrive at your seat, the very seat in which YOU now sit, and we arrive at YOU! Right NOW... This instant!

So where too now then?

But why stop our journey here? Let's continue into that screwed up wilderness that you identify with.

Through cognitive alleyways and boulevards that lay slightly to the left of your subconscious, to your own secret album of whispers: your own book of memories, that private mindscape bubble that you exist in.

Those memories of long long ago. Old yellowing photographs, refered to by 'Dylan Thomas' as 'The yellowing dicky bird watching pictures of the dead'. Did those times actually happen? Schooldays. That a*sh*le of a gym teacher, friends from times gone by, holidays on the coast building sand castles; and where do your childhood dreams play now?

The colours seem strange now, and there are no shapes for the colours to fill. Some distorted sound. Smells without scent, just a feeling of what it was like. A slight sadness for something precious that has been mislaid, or worse still, lost.

There *is* hope!

The others, the grownups — those who seemed to have no idea about what was important and what wasn't — would have called them our 'imaginary' friends, had they ever known about them.

But we of course knew they weren't imaginary at all.

Here's the good news: they're still around. They still want to play, and they're still up for a chat. They've always been there; they never left, *you did,* but they would just *love* to hear from you.

What happened to you? What happened?

We are now just three months old — a most powerful age to be. While out in our pram, we see on the streets the most messed up vindictive human monsters, and we smile at them with unconditional loving innocence.

We knew exactly what we were doing.

In the womb, oh, what perfection. We just simply know things without the need to analyse or understand; we just know. We *are* what we know. All of our senses are switched on and tuned in, and we hear voices from the outside.

But **before** this, it was quiet.

Nothing. Just us without form, without consciousness. This is different; this is unimaginable, with infinite potential. This is vast and endless. Here there is no beginning and, therefore, will never end. This is the realm of the daemon.

So what of this idea, then? This other you: This ancient Greek 'daemon', This beautiful Angel: this ever present guardian that if only we would allow would heal everything, and make it all alright!

A fairy fancy? Well, one of the greatest thinkers in history thought it important enough to die for after being accused of introducing new Gods to the youth of Athens, and forced to drink hemlock

"The favour of the gods," said Socrates, "has given me a marvellous gift, which has never left me since my childhood. It is a voice which, when it makes itself heard, deters me from what I am about to do and never urges me on." Socrates had the courage not to betray what he believed in even though it led to his demise.

That distant voice within — the source of inspiration. The silent voice which comes from nowhere, giving words of wisdom in moments of solitude.

> "I must have **been out of my mind**," You say.
> "**I was beside myself.**"
> "I don't know **what got into me**."

Napoleon talked of his daemon appearing as a shining sphere which hovered in front of him.

"They are intermediate powers of a divine order", says Apuleius. "They fashion dreams, inspire soothsayers".

"They are inferior immortals, called gods of the second rank, placed between earth and heaven," says Maximus of Tyre.

But whatever they are, one thing is certain:

THEY ARE!

Some actors in traditional cultures believed that they became possessed by spirits. They were in fact merely connecting with their inner selves/daemon.

Who do you think wrote these words? Who do you think is speaking to you now? Who do you think *I'm* speaking to? You know who I'm talking to. Something inside your head *knows* who I'm talking to.

The child is stronger, and more in touch with their daemon than we are as adults. As we grow, we question our instincts, impulses and our inner voice as we foolishly put away childish things. All we achieve by doing this is we stifle and block ourselves. We become scared to trust ourselves because we think that we, our developing egos, know better than our real, original selves. It is a rot that sets in; the self-lies start as innocent truth is pushed aside, and we are reborn as arrogant egoists.

Let's try and get you back to *you*.

Connection.

So I guess we must at some point then deal with the verdict question:

> "How do I connect with this authentic, original, magical, radiant, inner me?"

Once we open ourselves to this aspect of you that I have been banging on about, then *anything* will be possible — not only in our acting, but also in life. We will rarely need restrictive methodologies, which are restrictive by the very nature of the fact that they are methodologies, where we have to go through a process. We are restricted by a sometimes fallible system. As I have said, we already have within us that which the methods and systems seek to generate, except *we* are unrestricted. Anything else is clinical. The real thing is anything but clinical. It will never let you down, and it will deliver every single solitary time, guaranteed....**and you can take that one to the bank!**

To answer the question, then...

Well, here's the thing: there is no method to do this, of course. That would contradict everything I have said. There is no formulated system that I can tell you to follow, because that would be ineffective. We have

said that one doesn't arrive at truth and honesty by employing a system. There exists in this a conflict of interest. The truth drives the system, not the other way around, so clearly we must first attain the truth (the original you), and then this becomes the driver that turns the systems from **clinical to real**. The methodologies, then, become a whole different jar of pickles.

What to do, then?

The answer is 'Nothing'.

Yep, that's right, Nothing.

Simply **get out of your own way**, and allow it to surface. Feel it! You know it's there. Trust it. Release it —!

Maybe it begins with a primal, guttural release. Maybe a declaration. Allow it to release itself. There is no forcing it, or deciding to do it. There is no acting on an idea of what you think this might be. Simply allow it to come up from your core without placing any expectations on it. Its source is the divine spark that exists within all of us. Declare it to simply be. This is called, 'The Magic of Declaration'. We now authenticate it by giving it a name. Make your own secret name for this magical self. Name your daemon. Now give it an image; make it manifest in reality. Remember, this is nothing scary or weird. This is you. Meet you. I think you'll like yourself. Visualise your created image.

So, how do you get out of your own way? By throwing away desire, ego, conditions, and expectations— by just being *you*, unreservedly, uncompromisingly, unapologetically, and without censorship! Be free! Sounds great, doesn't it? **Yeah, it sure is!** It is the real deal— the *pure* you. **The little child you.** The honest you. The vulnerable trusting you. You the soul. The you that you have locked away. The you that you have almost forgotten, but whom you know is still there somewhere. *That* you. Your secret you. The one that you think that I don't know about. YES, THAT YOU! The one that perhaps for some might have been your secret imaginary friend. We all had some version of this at some point. Your secret inner voice. The one you used to play with as a child when alone, they are waiting to get reacquainted.

Trust, let it through, allow it to surface and take charge of things. Listen to your purest real thoughts, which come from the basic goodness that exists, because your child inside has a basic goodness. This child is the boss; He/She knows best. This is your inner voice, your instinct. Listen! Listen with love for this pure child. Your inner voice is never wrong. The magical you from where this voice comes has unlimited potential. You are limitless. You can do anything you believe you can. You can do things, (Acting if you must), with truth, power, and honesty without the employment of paint-by-numbers, restrictive clinical systems! "Good eh"?

By the way, all of this in its purest form has nothing whatsoever to do with acting. Actually, I really am not talking to the you, that is reading this book, because you want something conditional. You want the secrets of how to be a great actor. *I want! I want! ME, ME, feed my ego*. Nope. I'm talking to *you, the one* inside. Far, far more interesting.

In the name of all that is good, just be you. Be the you that you have not *been* for so long. Something inside you *knows* who I'm talking to.

Here's the thing: if when listening to your inner voice, your originality, if when feeling the presence of your own special self there is any doubt whatsoever, then it is not that aspect of you that we are talking about here. You *will* know it when you experience it. It will *never* lie to you. It will *never* steer you down the wrong path. It might stretch you, or take you out of your comfort zone, but it will *never* let you down. This is how you know it. The thoughts you get will never be unwelcome. This is *not* merely mind babble. This is not hearing voices that try to dominate your thoughts. If that's happening to you, then you should go to your doctor and seek professional help.

No, this is, in essence, simply reconnecting with yourself, but the real authentic original purest loving self. This is not a bad scary thing. This is simply *you. Nosce te ipsum* (know thyself). Allow yourself to be free. Let it matter. Listen. Be filled and overflowing with the reserves of Love that

you have for the child within, and for others. *Omnia vincit amor* (love conquers all)!

More good news. This is a free lunch! Your special self wants nothing back from you. It is unconditional. Relax! Do your meditation, evoke your totem animal, (If you are using an animal) and dwell in this sacred magical territory, and listen to your inner self. You do not have to be in a trance-like state; in fact, do not be. You can, once you are with yourself, carry on with your day; although I promise, you will engage with your day in a way that you have never done before. You are now limitless, totally confident, and happy. Do not try to drive this new you; instead, allow this new you to take control. It will take you to places that you never dared to dream about.

Now, as an actor, just trust it. *Let it* do the acting. There will be no acting involved. It will be real, honest, and truthful, when emotions will just come at the right time on cue and be done with once you leave the scene.

Magic.

This is the magic of acting. *Now* you have what the greats have. You have Marlon Brando-ness, or Meryl Streep-ness — just put your own name here. The great actors would have been brilliant anyway, despite their training, not because of it. They knew. Their training may have helped,

74

but they first had this very powerful and strong bedrock on which to base their training. Without this, the methodologies are just rigid systems that don't work. Now that you know YOU, the systems will work for you, because it is *you* that makes them work. *You* drive them. They do NOT, and cannot drive you, and now you are beginning to understand.

I would go even further and suggest that it was only the egotistical '*I want*' you that thought you need a system. The real you inside doesn't. Now, just to clarify something: this is not a duality here. This 'special you', and the 'everyday you' are one and the same. It is a matter of simply allowing this particular *aspect* of you to be the predominant you. Listen: Proceed.

Be open and vulnerable. This is your friend. It will always look after you.

This is top-draw important stuff; it's worth repetition and rephrasing for as many times as it takes.

As actors, you know the value of repetition. Right? Especially if you have studied the Meisner method. For those of you who are familiar with Meisner, have you noticed that very often the students of this system when in class seem to feel the need to shout a lot? Basically it's because they are acting on an idea, and not on impulse. "If I shout, then the teacher will know that I am experiencing high emotion, and I will feel that I am engaging with my truth" Sanford Meisner taught his students to 'act

on their impulses' so why do so very many of them make the choice, (because that's what they're doing), to SHOUT! Here's another thing. In acting, there are no merit points for 'The Big Emotional Experience'. It doesn't always have to be big, meaningful, high emotion. Sometimes, it can be just nothing. Because even nothing is something, and if that nothing is real, then it is *so* much more powerful in your acting than the forced 'Big Experience'.

Having said that, do not censor yourself. Work from your own beautifully flawed madness — your uniqueness, your very soul. You will *never* be wrong. In acting, without your special buddy inside, your acting might be a good impersonation, but an empty interpretation, no matter how many years or how much money you've spent on drama school because the wrong, ineffective aspect of yourself will have done the studying.

Acting is done on personality — your true nature, not the one your ego has fooled you into thinking is you. It comes from your secret state of 'being', led by the voice of your private self awareness. We have within us all that we need; we just have to connect. A human being's quality is more important to their acting than their abilities. It is *you* that is the magic, and far more powerful and interesting than any piece of so-called character work that you will be encouraged to do in the rehearsal room or the class room.

The Greeks might have called it the *Daemon*.

The ancient Egyptians spoke of the *Ka*.

The Romans called it the *Genius*.

In more modern times we may call it our guardian angel.

It could, I guess, be similar to the muse, although different. This is not a spirit that possesses you; it *is* you.

The ancient Greek actors also called this, 'The Gods descending' when performing in the theatre and they felt this state of magical 'being'.

In a kindergarten nursery room, ten young children sit in a circle. They are all aged between about 5 and 7 years old. They are then each handed a small musical instrument. One is given a wind recorder, one a small drum and a drum stick. Another is given a ukulele, another a whistle. A cymbal is given to another child, while another gets a tambourine. Coconut shells, a mouth organ or harmonica, and various other things that make some kind of sound. Our orchestra is now formed.

The members of our orchestra begin to tune up as they familiarise themselves with their instrument. They pluck, bang; blow, and then spontaneously, they all begin. No melody, no composition, just free improvised expression. They are each playing their own instrument but very soon they notice what the next child is doing, and they start to play in harmony with the next person. The plucking of the ukulele now has the

same rhythm as the child beating the drum. This is just happening naturally. The child with the whistle decides he now wants the coconut shells, so he stomps over and takes it away from the child who had them first. This child becomes agitated and upset. They are reacting very honestly, in the moment, without censorship. The shells are taken back and things continue. In the meantime, the tambourine and the recorder have gone into a duet accompanied by the whistle. These children are in free flow. They are acting on their impulses, and they are experimenting like no one is watching. They are letting emotions loose, and they are reacting to each other in the moment. *Brilliant.*

Same in your acting. Let the children above be your teachers!

To reiterate: as children, we are closer to this 'other us'. The child is stronger than we are in this way. As we grow, we question our instincts. We think we know better, and we put away childish things. How could we be so stupid? We think our developing ego knows better than our original magic. We make a life of this stuff, and carry it all with us. A mistake. As one man once said, "Become as little children". (Mathew 18.3)

There is a great section from the short story, "The Canterville Ghost" by Oscar Wilde. In it, the ghost appears to a little girl and says:

"You will see fearful shapes in the darkness, and wicked voices will whisper in your ear, but they will not harm you, for against the purity of a little child the powers of hell cannot prevail".

Dry your eyes, my friend. Everything is fine! The daemon is awakened; and it is to you, the daemon, that I am now speaking to! Not to *YOU*, with your egotistical 'I want' Philosophy of theatrical low systematic methodology: But to *YOU*! Yes **You**: you know who:

Do I mean you who is reading this? NO I don't. I'm talking to YOU! YOU inside right at the back: the 'other' one. The secret one. Something inside your head KNOWS who I'm talking to. SO, Great to meet you!

Ladies and gentlemen, the pandemonium has now convened.

William Shakespeare said:

"This above all: to thine own self be true"

Relaxation/Meditation

One of the most important things an actor should do, if not *the* most important thing, is simply relax. Now, I know that many of you will have been told by the systematic teachers how to relax. "Tense all of your muscles, and then let go", "Roll your head round and round in circles while letting out a constant AHHH sound", or "Breathe in for three seconds, hold for three seconds, breathe out for three seconds". *Arhhh!* Such a lot to do; you're supposed to be relaxing. Why not just simply flick the relax switch and just *relax*?

Breathe normally; sit quietly and breathe in, breathe out. Eyes open or closed, it doesn't matter. Let everything go loose. Clear the mind. Abandon all thoughts of acting, abandon all thought and simply 'be'. Do this without any result intention. Do not do this so that you can relax in order to be a better actor. Do not let this kind of egotistical intention infringe on what you are doing. See what happens, but do not do it with any expectation. Just do it. Just be.

Yeah, yeah, I know, you've heard it before. Well, bully for you, but here I am suggesting that you do it with the above mindset — i.e. for the sheer joy of relaxing and letting go. Not for any causal 'actor-y' reasoning.

So how do we just flick that relax switch?

Well, a great way is to do a quick, simple meditation. Do not use this as some kind of methodology, but rather simply as a simple relaxation pastime.

Here we go then:

Go to a quiet room. Turn your phone off. Loosen any tight clothing. Take your shoes off. Sit upright in a straight-back chair. Keep your own back as straight as you can without straining. Relax shoulders. Relax muscles; no need to tense up first, just let go. Now become aware of your breathing. Breathe in, breathe out, and repeat. Breathe normally, but become aware now of the outward breath as it dissipates. Just continue to do this — *In, out, In, out* — placing awareness on the outward breath. This is not a big deal thing. Do not invest concentration specifically on the outward breath, just be lightly aware of it dissipating as it is naturally released. That's it. That's all.

Now, what will happen, and it WILL happen, is that random stray thoughts will come into your head. At first, they will come up every few seconds. As this happens, remain aware that this is just a thought; irrespective of the nature of the thought it is just a thought. Notice that you are thinking. Be aware that you are thinking, that a thought has come in, and notice the thought. Do not get caught up in the subject matter of the thought, simply acknowledge and notice it. Do not invest in it, and do

not feed it by continuing to engage with it. Just be aware that you have had a thought, and now leave it, and return to the breathing. Focus back on your breathing, and every time another thought comes, be aware that you are thinking, notice it, and leave it to return to your breathing. That's it. Do this for 15 minutes in the morning, and 15 minutes in the evening. After a couple of weeks, you will be so much more relaxed both in your mind and in your body.

I know that this is a very basic breathing meditation, and you may be well versed in the art already, but the above will be hugely beneficial wherever you are with your practice. Just do it without thought of the result. Concern yourself only with the process.

PART TWO: Industry Stuff

Now I know that there are already books out there that deal with this stuff. So, what of it? Well here it is again, in plain English and telling it the way it actually is, in a no-nonsense way.

If you are new to this business, (and it IS a business), then at some point, you will need to start taking steps towards the industry. The industry will not come to you. There is a massive difference between doing great creative work in class and the reality of the industry. The industry, generally speaking, doesn't care about you or your integrity. It cares about one thing and one thing only: whether it can make money from you. Very often they will be looking at very good and very popular clinical, paint-by-numbers actors because this is a safe way to go. The tried and tested route. So, as I have said, the industry does not need to come to you. There are thousands of actors out there who have made their mark already. Ergo, you need to consistently approach the industry yourself. This is a thing that not only new actors need to do, but also actors returning to the business after a break, or even long-distance actors.

What follows are a few tips and reminders of how to do this.

Headshots:

The very first port of call an actor has when promoting themselves is their headshot. It is not their CV, or their show reel or demo reel. It is not a letter or email, it is not a phone call; it is the headshot. This is the very first thing an agent or a casting director, or a producer will consider, and it is the very first thing that will register with them, though it is estimated that they will spend no more than three seconds looking at it as they get so many. They need to see what you look like, and thereby hangs the rub: what do you look like?

The majority of headshots that I see look nothing like the actual person. Incredible, isn't it? But true. These 'headshots' have been photo shopped, airbrushed, and everything else. The actor/actress has had a special hair makeover, and they are wearing enough makeup to stock the makeup department of Harrods. The result is a glossy ego-filled tinsel town idea of whatever they imagine they need to adopt in order to get the roles. They send in this picture, and then when they walk into the casting room, the people running the casting session look at each other, and then at the candidate, and they say, "Who the hell is this?" It looks nothing like the person in the photo. So, if you insist on your headshots being the way I just described, then at least look that way every time you go for an audition. If that's the way you choose to really look in your life, then it's fine, but most of us just look like a normal human being. So here's the

thing: **Your headshots should look just like you do on a normal day**. The same you that your family and friends know, warts and all. Casual, normal, discreet makeup, hair however you would always have it — just the real, un-actor-y you. Far more interesting. THEN, you can make slight, and I mean slight modifications to meet the requirements of each casting.

For decades the unwritten rule when it came to headshots was Black and White, and 8X10 in size. I am perhaps a little bit old school, and I still prefer this, but in recent years things have moved more towards the American way of doing things. Now, the trend is to have colour shots, and with the digital age, you can send out shots electronically. It is crucial that you have your headshots taken professionally by a photographer who specialises in taking actors headshots. They will know how to just take a really great, natural picture that brings out the real you, without any foppish window dressing.

At the time of writing, you can expect to pay anything from £150 up to £1000 for this service. I would advise you to spend as much as you can afford, as I can't stress enough the importance of getting your headshots right. If you are new to the world of headshots then perhaps you should be looking at a price of around £200.

Your session will last for around one hour, and the photographer will take approximately 50 shots. Take a couple of distinct outfits with you. You will

then be sent some low-resolution images from the session. You then need to choose maybe six to be sent to you in a higher resolution, which you will use as your gallery of casting shots.

Do not choose these yourself! If you have an agent, let them choose. If not, let your friends or family choose. They will pick the shots that are closest to the way the real every day normal you comes across, which is precisely what is wanted.

Just trust me on this one.

I once knew an outstanding actress who rarely worked. We talked about this, and I asked to see her casting photos. When she showed me, the first thing I said was, "Who is this?" Her picture was her, but with loads of makeup beautifully applied, a hairstyle that must have been extremely expensive, and she was wearing designer fashion clothes. The photo was in colour and had been airbrushed to give it a softer tone. Her eyes had an extra sparkle, and she looked like a Hollywood film star. It was a great shot, but totally useless as a casting picture. It looked nothing like the real girl that I knew.

In life, she had a more relaxed style — untidy hair, jeans, t-shirt, no makeup; in my view, much more interesting. She sent up her glossy image, and based on this picture, she was called in to audition. On the day, a totally different girl walks into the audition room. This could

certainly be the very reason why she didn't work too often. I advised her to get some more photos done, only this time to be more honest about who she is. She now works all the time and is a household name.

If they are looking for *you*, then they will find you through your photo. Make sure that what they see in the photo is what they see when they meet you.

Lastly, in the words of American casting director Patrick Tucker, "Your face already has a performance stitched onto it".

Agents

If you are a newcomer to the world of acting, then I know one of the questions that will be on your lips is, "How do I get an agent?"

O.M.—actual—G! This is a terrible question to ask a boy. How do you get an agent, indeed?

Well, there are literally hundreds of agents out there. Some are great, some not so great, but the vast majority of them have one thing in common: they want to represent actors who will make them money. Therefore, they want you to work, so if you are lucky enough to be represented then for this reason you can rest assured that they will be doing all they can to get you into the audition rooms and casting suites. They will all have a different set of contacts and they will all have a different relationship with those contacts.

Choose your agent carefully, just as they are meticulous about who they choose. You will be entering into a partnership which could last for many years, so be mindful.

Here's what I suggest you do.

See your agent as a partner. You do not work for them, and you are not their employer. Within this partnership, they will work to benefit both of you. So here is a bit of agent-client protocol.

DON'T HASSLE:

If you don't hear from them for a while, then know they are working on your behalf in the background, and that they will be in touch just as soon as they have a meeting for you. Do not bombard them with phone calls demanding to know what they've been doing. I can tell you what they've been doing. They've been busy trying to get auditions for you. Sometimes, things can go quiet for a while. Don't worry; your agent is doing their best for you. It works in their favour because — don't forget — it's a partnership.

Always stay in touch. They need to keep up with exactly who you are. They need to know what character type you best fit into. This will change over time as you change. So, call them every so often and make an appointment to drop by the office to keep them in the loop. Take in new photographs, along with any relevant news you may have, like how you've recently learned to ski for example. They need to be updated. When you have been for an audition, always report back to your agent on how it all went, and then *forget about it*! If you get the role, your agent will be the first to let you know. If you do not get the part, it's not your agent's fault, and it's probably not your fault. Best to move on.

COMMISSION:

OK. Now, this is not negotiable. Always, *always*, pay your agents commission on *all* acting work. Even if you got that work yourself, still pay them their commission. That's the deal. Your agent will still handle the contract, so commission is payable.

Always be available for contact. Sometimes they may have an appointment for you which they have been chasing for weeks! If they then can't get hold of you, how long do you think they will continue to work for nothing? Be there for them, or if you are going away on holiday, for example, always tell them, and give them a contact number where ever you are.

BE LOYAL:

1. Be Loyal! Over time, your agent will build up your CV. They will have worked earnestly on your behalf. They are good business partners. Do not throw this away. Sometimes, you might think about moving on; if you really feel it's time, then do so fast, and cleanly. Sometimes, if you become very successful, another agent might try to get you to defect over to them. They will probably be a top agent, but it was your current agent that built up your CV. Know the value of this. Play fair. On the other hand, if you feel

that things have broken down between you and your agent, then go!

A Warning: *never* pay an agent a registration fee to join their books. If they ask you for money upfront, just thank them politely and leave. No agent worth their salt will ever ask you for money in this way. Agents make their money from their well-earned commission charges on the work they find for you.

Auditions

If you have turned straight to this section, then you will need to go back and read all the preceding chapters first. I have placed this chapter at this point in the book for a reason. It will, I believe, be beneficial to you, to prime yourself with the preceding information to receive what I have to say about auditioning. What I am saying in this chapter is basic enough; no big deals, depending on what level you look at it. Anyway, it's your call, so here goes.

Whether you are a drama student, or a seasoned professional, let's talk briefly about auditions!

Now, I imagine some of you are holding your head in your hands, clawing at your hair in anguish as blind panic tears through your being, reducing you to a gibbering wreck! Well, this is how a lot of actors, both newcomers and seasoned pros, walk into the audition room. I've seen it firsthand.

A couple of things happen now. You become blocked. All creativity and spontaneity goes out of the window, and also your memory blanks out! You huff, puff, and fluff, you sweat, and for some reason you find yourself speaking in a strange voice which is not your own, and you make crazy faces, and this happens, sometimes in the most amusing way. All the

work you did the night before in front of the bedroom mirror, all of this means nothing.

The whole reason behind this stuff happening is:

You are not relaxed!

Relax, relax, relax! This one little word is the most important word any actor will ever learn! Yes, it is *that* important! *Re-lax!* This can be a useful skill in any situation, but it is an essential skill if you are serious about being an actor.

As actors, when we get an audition, the anxiety begins. We want to get the job. We want to make a great impression in the casting room and show them what brilliant actors we are. We want them to like us so that we will get the approval of our agent when we get an offer. It becomes imperative to us on loads of levels, not least that we will be able to pay our rent, and eat. We resolve to try and be our best, and we work hard to learn the script, think about the character, analyse, come up with a couple of different ways to play the scene, then we go over it again and again. We study carefully what the other people or person in the scene says to us, and we look for subtext, etc. We so want to deliver a great performance on the day of the audition, to be such a great character, that we forget about who *we* are.

I have already said that we can only ever be us. We can't be somebody else. Everyone else is taken. So, when a TV company, or a theatre, or a film company set up an audition day, just what are they looking for? They're looking for you, and they don't quite know who you are until they find you, but they will know if they have found you within 30 seconds of you walking into the room or seeing you on tape. They are looking for what they see as the essence of the 'character', emanating from your core. I have told you that the character is you, and they want to see this real aspect of you to the fore as soon as you walk in. They want to see the character, as written, walk into the room as a real human being. When they see this, they become very interested, and you will have captured them.

Now simply bring up that particular aspect of yourself that fits, and then just be you. No acting. No thinking. Be you, and if that's what they're looking for, then you will get the role. Invariably they don't know exactly what they're looking for until they see it. If you don't get the role, then you weren't right for it anyway.

So, let's go into the things that will ensure that you do a great audition — one that not only the audition panel will be happy with but one that you, yourself, are happy with. An audition that has a better than average chance of landing you the role.

1. **Relax!**

 The single most important thing an actor should learn to do. Refer to the chapter on relaxation, and simply have the courage to be yourself.

2. **Be on time!**

 An 11.00 appointment time means 11.00! Not two minutes past 11.00. Be there *on time*! If you are late, there is a good chance they won't even see you. If you can't turn up on time for the audition, how do they know you will be on time for the job? It is imperative that you be on time for work, because TV, film and theatre companies run a very tight ship, and a late actor wastes valuable time. It can end up costing the production company a great deal of money as they have to reschedule shooting to accommodate the actor's poor timekeeping. Major problems! Which you will not be thanked for. You might even be replaced.

3. **Read the script and learn the lines!**

 Learn the lines without imposing anything on to them. If this is not possible (sometimes, you don't get to see a script beforehand, although you'll usually get it the night before), well that's it then isn't it? You can't, so no worries. Just do your best with sight-reading when you get there.

4. **Dress for the part**

 Turn up for your audition or casting session dressed in a manner that suggests the character you are up for. As an obvious example, if you are up for the role of a banker, you will need to go in a suit and not jeans and trainers. If you are up for the role of a pirate, then you might wear a flowing shirt and earrings, showing tattoos if you have any. There is no need to go dressed in full-on pirate costume; just suggest it in your overall dress and demeanour. The panel will like it if you show that you have given some thought to your meeting.

5. **Attitude!**

 As well as dressing for the role, you also need to adopt the attitude of the character you are up for. For example: if the role is for a person in the depths of despair, and you go springing in like you are the happiest person on the planet, full of smiles, and with a bounce in your step, then you will not make a great impression. At the same time, you don't need to be sobbing and holding a razor ready to slice your wrist. You should walk in with an attitude that suggests a mood. However, at some point, you'll have to smile at them. They also need to like you.

When it is all done, and you have done your best, and there is no more to be said, you simply say "Thank you very much", and you leave without

further ado. Do not try to make friends with everyone, or linger talking: no need to shake hands with everyone; just smile, say thank you, and leave. That's it. Never ask the people you've auditioned for, "Was that ok?". It simply is not done. Just finish your audition and leave, quickly.

This may all seem obvious to you, but let me tell you: I've been on the audition panel a few times, and it's amazing how many actors seem to be blind to the obvious!

So, these are just a few points that you should remember when attending auditions. There is so much more to it all than the few words I have written here, but this will be a start.

Remember that you have been asked to come to the meeting in the first place because they think there is a chance you can do the job. They have seen your CV and watched your showreel if you have one. They have asked to meet you because they already think you could do it. So, be encouraged by this. Do not beat yourself up if you don't get the job. This does not mean that you did a lousy audition. It only means they saw somebody who in their opinion fitted the role closer to how they envisioned it.

One more thing. We know that actors are a friendly bunch. However, if you bump into another actor you know in the audition waiting area, let me ask you a personal favour. Don't start your chitchat there and then.

Arrange to meet for a coffee after. Don't distract other people like me who are there to concentrate on getting the job. I don't need to hear your chit chat. Talk after, in the café, next door. No one else is interested in having to endure your social banter.

Typecasting

Typecasting is inevitable. Get over it. In the vast majority of cases, you will fit into a certain casting bracket, where agents and casting directors see you in a certain light because of your 'character type'. You can always play against character of course, and this very often works in a very powerful way.

For example, you might be 6'11" with a body like Schwarzenegger but be the victim of bullying. Generally speaking, though, a man of this description will probably be cast as a hard man. There are of course grey areas: if you are up for the role of a serial killer, we can ask, "What does a serial killer look like? Well, who can say? They come in all shapes and sizes, as a look through criminal history will show, but casting is not only about physical appearance. It is about what the actor exudes' from inside.

Correction! Not what the 'actor' exudes, but rather what the human being inside the actor radiates. In other words, who you are, and this is what the casting people are really interested in. So simply be you, warts and all. It's all good. Why try to be something else, when the real you is

infinitely more interesting than some plastic pretence? You will be cast according to who you are. Fortunately, we are many things. We are multi-faceted, with all of the Greek archetypes inside of us. The culmination of all of these aspects of our selves makes up 'us'. This is who you are, and you will be cast based on this.

So typecasting is, as I said, Inevitable. Get used to it. Accept it, and welcome it.

Let's take a closer look at just what typecasting means. If you go to the cinema, you will probably know exactly the kind of movie you are going to see by the names of the stars in it. A Jim Carey movie is, nine times out of ten, going to be a comedy, and Carey will be playing a bumbling geek. Bruce Willis will usually play a hard man.

What 'type' do you think you are?

Who are you when you are in 'standby mode', when you shake off all the pretence and just be yourself, who are you? When you return to your inner 'Home page', who are you? Well, this is what casting directors are looking for, and your friends pick up on. You will normally be cast according to this, so why not embrace it? Work with it, instead of trying to fight it. Yes, we all know that you are a wonderful actor who can play any role at any time, but the truth about this business is that casting will slot you into a character type. Going back to Jim Carey: imagine him

playing Rocky, the part made famous by Sylvester Stallone. Jim's a great actor, but why would anyone think of him as Rocky, when there is Sylvester Stallone?

But what about actors like Daniel Day-Lewis, you might ask. He surely isn't typecast. He can play any role through his method of totally inhabiting the role on a very full-time basis. Well, Daniel, and a few others, are exceptions to the rule.

It's as simple as this. Making a movie costs millions and millions of dollars. The people putting up the money do not generally want, or need, to take a risk when casting, so they book the person they know, by looking at their back catalogue, will do the job. It is usually the executives who have the final say over the artistic team. That's just the harsh reality. Typecasting is mostly based on how you look — your physical appearance.

Self-Taping

Time was, when getting an audition for film or TV meant getting a call from your agent with an offer of an audition or screen test. You would get a time of arrival and an address. If you were lucky, you'd be given your sides (the section of the script with the scene or scenes you will appear in) and the name of the director or producer that you'd be meeting. When you got there, you taped your audition. The above still applies, to a

large extent. However, things are changing. The phenomenon creeping into our industry now is a new kind of discipline: 'Self-Taping'.

So what exactly is self-taping? Well, it's pretty much how it sounds. There is no physical audition, so you record yourself. You get a call from your agent giving you the details of the role you are up for, and you will be sent the sides, and that's it! No going anywhere, no casting directors or producers to meet. Just you and the script. It is now your job to produce your own audition, and put it all on tape, and send it back to your agent, and then He/She will forward it on to casting, or the production company that will be making the film.

Easy Peasy, eh? No guidance, just you, a camcorder, and a script in your bedroom, or sitting room. By the way, they need this back by 10.00 am tomorrow morning. Alarm bells! Stress! Panic stations! *Nil desperandum* my friends — do not despair — for here is what you do.

Firstly, relax. There is a task to perform, and you do it with the energy that the task demands — no more, no less. You might need a friend or a family member to help. It is possible to do this thing alone, but I think it is easier to have a second person to operate the camera, etc. By the way, the camera on your tablet or phone is also fine. These are good enough for the purpose. Just be sure to film everything in 'Landscape' mode, not 'Portrait'.

Start by reading the script/sides. If you are lucky enough to have been sent the full script, then read it front to back! Otherwise, make do with reading the sides if that's all you have. Sounds obvious, but you would be amazed at how many actors don't even bother to read the script if they have it— and believe me, it shows.

So, having read the script, I would say that you should now learn it. There are two schools of thought on this: One says that you should learn the lines for your audition, and the other says that you should not. The reason given for this is that an audition is only a reading, and that is what it should be: A Reading. If you learn the lines, the temptation will be to work on them and come up with some sort of preconceived performance. I say learn the lines, but learn them without imposing anything. Just learn. Make general choices, but at the same time make your choices bold! Don't worry that they might be the wrong choices. Who's to say exactly how a scene should be played? The people watching your tape want to see something of *you*! So, try it out a few ways without trying to put in a perfect performance at this stage. I can assure you that they are not looking for that. They just want to see *you*, and how you come across on film.

Now, I appreciate the old adage, 'Less is more'. As an actor you don't need to do anything as you put it all inside, but I suggest for the purposes of the casting only, you 'do' something albeit subtly. They just want to see

a range. Have fun with it, Acting and life are about being, and that is 'something'. So try it a few ways on tape. Be big! Be minimal. Watch them all back with your helper and pick the three you like best. Now, have the person helping you make the final choice and send in two different versions. You will probably disagree, but accept this choice. They will be more objective. Trust them. You are not doing this for you; you are doing this for other people. Your helper *is* other people!

Self-taping is the same as going to a normal casting.

You learn the lines, you perform on film, and you leave. With self-taping, you also get the luxury of being able to do it a few times and you get to choose the best take. Very good so far. In a real casting situation, you might get five minutes in the room. I suggest that with self-taping, you shouldn't spend more than a half-hour on it all. This is enough: If you spend hours on it, you risk 'overkill'. Get it done. Get it sent. Now forget it. Relax. Go and do something else.

A few words on the Technical side of things.

Shoot on a camcorder, or a phone with a decent camera. Either works.

The people who have asked for this tape are not expecting, nor do they want, a glossy and, in your opinion, well-made piece of film. You will never do it as well as the filmmakers, and they don't expect you to. Just

do it as per any casting session, which normally involves you sitting in a chair directing the lines to a position slightly off-camera.

You can dress in a way that might suggest the character Shoot in medium close-up (i.e. head down to mid-chest). At some point, move in for the close up; just on the face. When your helper is reading in for the other person, direct your lines to them. Have them stand very slightly to the side of the camera. Do not speak directly down the camera lens, unless the role specifically demands it.

You must also film what is known as an 'Ident'. Film this separately.

It is simply a shot of you being you. Shoot this directly on in full length. Here, you *do* speak directly into the camera lens so that in playback you will be speaking directly to the person viewing. Just say your name, and contact details. Name your agent, otherwise, include a direct phone contact. Now, show both of your profiles and return to face front and now say your height. That's it. The ident should be around five seconds. Remember to smile. Be nice; this is a sales opportunity.

Well, that's about it, I guess. Not rocket science, but if you are anything like me then sometimes it's good to be reassured of the obvious. It's a deal less stressful than you might imagine. Just film yourself in a straight forward way, speaking the lines, having made a couple of choices, but

without imposing too much onto the scene. Leave the directing to the director, and the filmmaking to the filmmakers.

Good luck with it all, and don't panic!

The Protocol, Discipline, and Business of Acting

In order to be a professional actor, it is vital to have at least some sort of rudimentary idea of what the above three words mean in terms of the acting business. Being an actor is fundamentally about knowing yourself. It is having a heightened awareness of the world around you, it is being in touch with your emotions, and it is being open and free to express those emotions. It is also about dedication and a hundred-and-one other things. This is the art of acting, but the industry is also a business.

The people who make movies do so, for the most part, to make money. Livelihoods are involved here; not only yours, but those of other people, so protocol, discipline, and good business are essential. Let's take a look at some do's and don'ts, what is acceptable in the industry, and what is not, and some unwritten rules.

May I, first of all, say that for myself, being the original 'Rebel without a Cause', I am just as repelled by rules, red tape and grey-minded bureaucracy as the next guy. For me, it stifles freedom because you have to do things the way 'the man' says. Here's the truth of the matter: the people that run this industry — the big wigs, the businessmen and women, the moguls, the producers — well they pay the piper, so they call the tune, as the old saying goes.

It's as simple as that, so just accept it, and know that if you want to be an actor then on the hard business and protocol side of things you have to play the other guy's game, and jump through a few hoops. Annoying, isn't it? The truth is, though, they understand exactly what they're doing and why.

Ok, that's it! I can't go on! That was hard for me to write, advising you to be compliant and to defer to the judgment and rules of others. All rules are made to be broken, but if you don't want to upset people then be careful how you break them. Unless, of course, you just don't care, and you are determined to do things your way or not at all, as many great artists in the past have done. You become the rule maker instead of the rule breaker. But really and truly, before you have the right to break rules, you have to know exactly what you're doing based on the fact that you have put in the years. I can only advise here of the expectations that will be placed on you as a general rule. Thankfully, not in every case. So let's deal with a few simple ones.

BE ON TIME!

You can be a little early, but never, never late. That's NEVER!

I think it was dear old Oscar Wilde who said, "Punctuality is the politeness of princes".

NO DIVAS

One great thing about this industry — and there are *many* — is that the vast majority of the people are really good people. They are friendly and professional, but with an easy-going sense of fun. So, a bad apple in the barrel is not welcome. I have worked on a lot of films and TV shows in my time, and sadly sometimes have come across a bad apple actor.

They often have some conceited, egotistical false sense of self-worth. They walk around like they are some big star — and sometimes they *are* — they complain about trivial issues, they make demands, and they have a very dismissive attitude to other actors. In other words, they 'reckon' themselves. Well, let me tell you this: no one else reckons them. They are a pain in the neck, and they make for a stressful atmosphere on set, and as we all know, stress is the enemy of the actor. They want the whole world to be about them. They are selfish as actors; they work in a bubble concerned only with themselves.

These people are to be steered clear of at all times. Unless they are a huge international megastar, they will usually not be employed again. Here's the thing, though. In my experience, the bigger the star, the nicer they are. They have nothing to prove and are generally very kind to their supporting actors.

Here's the lesson:

Be nice! That's easy, isn't it? Just be nice. Be easy to work with. Be a normal human being. You are very fortunate to be there. Yes, you are a good actor, that's why you got the job, but the rest of us don't need you strutting around like some puffed-out peacock displaying your feathers. It's annoying, alright? And be especially nice to the crew. They can make or break your performance on film. These are the guys that make you look good, and they are there to do just that. Upset them at your peril. Be helpful. It's not all about you.

Here's a short illustration of the sort of thing I'm talking about:

A few years ago, I was working on a BBC sitcom. We were on location, and a certain actress, whom I will not name but who you would know, turned up late because she was not ready to leave when the car that was sent to pick her up arrived at her home. The driver radioed in to say that there would be a delay with her arrival on set. This straight away meant that things needed to be rejigged in terms of hair and makeup, costume, etc. When she finally did arrive, she was asked to go straight into makeup. This she objected to saying she wanted coffee brought to her trailer, and that the makeup team go to her. Once on set, she would argue with the director over trivial things that really didn't concern her, like another actor's blocking. She spoke down to the crew and dismissed other actors she considered to be 'beneath' her. She was not invited back for the next series. Case proved, m'lud! So keep yourself in check!

Casting Directors

Look, your agent will most certainly have a great many more casting director contacts than you do. Trust them. They will put your name forward when appropriate. However, it is fine to contact a casting director directly, but tell your agent of your intention to do so. They can then follow up on the initial contact.

If you do decide to do a bit of a mail-out, there are certain bits of unwritten protocol you need to know. Now, as I have said before, none of this is set in stone, but at the time of writing it does seem to be a general fad to do things in a certain way.

It seems that most casting directors prefer initial contact to be via land mail. Do it the old-school way; put it in the post. Send them your Photograph, a CV and a covering letter. Make the covering letter short and to the point. That's it! No more at this initial stage.

Do not, at this stage, send unsolicited showreels. This they can see by request. You can follow all this up a couple of weeks later with an email, in which you can include a link to a reel if you have one. If you don't, get one. Never phone a casting director unless you have been invited to do so. Can you imagine just how many letters and emails they get each and every day? There just isn't enough time to deal with them all, if they are to get on with the job of casting', which is, of course, their main function.

If they want you, then they will find you, but there's no harm in dropping them a line now and again. Do not be offended if they simply don't reply at all. It is not personal. You will at least be on their radar.

Now, you might quite understandably find all this somewhat annoying. "Why", I hear you ask, "do I have to bow down to someone else, and promote my business (me) in the way that these 'others' dictate? Why can't I promote myself in the way that I choose to? Surely, I can run my own business in the way I see fit, can't I?" Fair point. Well, unfortunately, that's the way it is, buddy. Comply, and be in with a chance, or be a rebel and possibly miss out. Being a rebel is always good, in my opinion, but it's a risk. Most things that are worthwhile involve risk; I am merely telling you about the safe, conventional, tried and tested way.

I must just tell you about an actor friend of mine. This story always makes me laugh. My friend is a very good and reasonably successful actor. He wanted to write to a mega big casting director who was casting a major Hollywood movie. So my friend, let's call him Dan, looked up the current contact details for said casting director. On the website, it gave instructions as to the method of contact. It said something to the effect of, "Contact by post only, sending a black-and-white photograph and CV. Place all in an 10/8 envelope, marking the back with a red star. No phone calls. No showreels. No follow up contact".

This puzzled Dan. "Why can't I just send them my stuff in a way that I believe will best promote me?" He wondered. "After all, I am the one doing the promoting". Anyway, Dan reluctantly complied, but added his own instructions for contacting him back, should they wish to reply. I guess he thought that if they can make rules about contact, then so can he. So, he told them that the method of response should be via an audio/visual link on youtube in the style of an extremely camp drag queen!

Needless to say, he did not get a response. The reasons for this could be many, but I sincerely hope that it's not because they lack a sense of humour. So, play the game and get the gig, or take your risks. I know which one I prefer, but that's my business.

CV's

Along with your photograph, your CV is your first point-of-sale. I'm sure that most of you will know that it stands for *'curriculum vitae'*, from the Latin, 'life-information'. So include on your CV information about your life — not only your acting life, but also information about you. It is all relevant. Focus on acting, but also include things like where you were born, your first job after leaving school (no need to give details of the company or dates or anything like that, just what you did), etc. All experience is good. Mention anything unusual about yourself. Seven feet

tall and covered head-to-toe with tattoos, for example. Ok, an extreme example, but you get the point. Include all personal details: height, weight, all costume sizes, including hat and glove size. Include details of any training, your agent's contact details, along with all non-acting skills you have, like sports, driving, horseriding etc. Be honest! Do not say, for example, that you can ride a horse if you can't.

Now list all of your acting credits, and categorise them into sections: film, TV, theatre, radio, voice etc. Try and keep the entire thing to one sheet of A4. Include at the top a thumbnail picture of yourself. The design should be standard. Check other actors' CVs online. Here's the rule part: *never* lie on your CV. It is not helpful, and it is wrong.

On Set

On-set protocol is a book on its own. Film and TV sets are very busy places, where a lot of people are working hard for a common cause, where things run with great precision. Shooting days cost a tremendous amount of money, so set discipline is vital. Here's just a couple of rules:

If the 1st Assistant director calls, "Going for a take studio, silence on set, please," it means SILENCE! No noise whatsoever! No just finishing off what you were saying to the person you were talking to, no shuffling of feet — in fact, zero movement. *Silence*, OK? It's incredible how many

people just don't understand this simple request, which is why 1st Assistants end up shouting a lot!

Here's one more: when filming, if you're not involved in a scene, and you are not needed on set, then do not hang around getting in the way! Go off to get a cup of tea or something. Leave the set. The 2nd assistant will find you when you are needed, but always be in 'standby' mode. Let someone know where you will be.

Oh, yes. Never, ever hassle the star of the show. They could be huge international stars, and they have a huge job to do. They will usually be very nice people, but they really don't need people being starstruck with them while they are working. Give them space, let them concentrate. So just be mindful of the way things work, and don't be a spanner in the works.

I have been an actor for a very long time now, and have worked in film and television studios around the world. It struck me very early on in my career that it is of vital importance that the director understands the acting process. Sounds obvious, doesn't it? It *is* obvious, but you will be surprised that certain directors appear to have zero empathy or understanding of the acting process. It is also useful if the other crew members have a rudimentary understanding of the work an actor does.

With understanding comes more effective communication, and thus a more desirable outcome.

Now, here's the thing: it is just as important that the actor understands the roles of the crew members on a movie set. Going onto a big film set for the first time can be daunting. There is a considerable amount of activity going on all around you all the time, and guess what — it is all happening so that *you* will look good on film. They are all there for you and the other actors, so it would be rude to have no idea about who these people are who are collaborating together for *your* benefit.

You need to know your way around a movie set and know who does what. So here's a quick who's who.

Q) Who is the Production Manager?

A) This is the person who works closely with the Producer and the director, making certain all is going to schedule and that the production is staying within budget. The Production Manager is there to keep things running smoothly by working with all crew members.

Q) Is the Production Co-ordinator a different role?

A) Yes, slightly. This person will work with the 2^{nd} A.D. on call sheets for actors and crew. They order anything needed on a day-to-day basis and are in charge of all transport.

Q) What does a Location Manager do?

A) A Location Manager finds filming locations. Once found, they will co-ordinate and manage all that is involved in being there: hotels, permissions, toilets, informing the police, and making everyone aware of safety issues.

Q) Who is the 1^{st} Assistant Director?

A) The 1^{st} Assistant Director is one of the most important people on any film set. They are the director's voice on the studio floor or on location. They are the link between the Producer/Director and the actors and crew. They know everything that is going on. This is the person that will keep things flowing smoothly; they are in charge of set discipline and morale. They think ahead and solve problems before they begin. Mostly, they manage each 'shot' along with the DoP (Director of Photography).

Q) And the 2^{nd} A.D supports the 1^{st}, I suppose?

A) Exactly! Not rocket science, is it? They arrange cast pickup's, help the Production Co-ordinator with call sheets, arrange and book the extras and look after the cast as they arrive for work.

Q) The 3rd Asst. Director?

A) The 3rd A.D. coordinates the extras and works as a 'runner'.

Q) What is a DoP?

A) DoP stands for 'Director of Photography'. They are in charge of how the film will be shot — the visual image. They will also be an expert in film lighting and will work with 'sparks', or the electricians, to light the movie.

Q) What is a 'Grip'?

A) The Grip is in charge of all camera 'bases'. i.e. They lay tracks for moving shots, camera cranes for aerial shots — they take care of all camera rigging, in fact.

Q) Who is the 'Gaffer'?

A) The Gaffer is the chief electrician, in charge of the power supply and all connections to that power. You might have

heard of the film crew role of 'Best Boy' and wondered what that was. Well, the Best Boy is the assistant to the Gaffer.

Q) What does the Camera Operator do?

A) This one's cut-and-dry: they operate the camera under the DoP's direction.

Q) What is a 'Focus Puller'?

A) Self-explanatory, really. They are part of the camera crew, and they load film, check the camera's gate after each take, and changes focus and lenses during shooting.

Q) What on earth is a 'Boom' Operator?

A) They operate the large microphone on the end of a long pole, or 'Boom', for certain shots. They also keep a record of all sound takes.

Q) What is a Production Designer?

A) The Production Designer oversees the 'feel' and 'look' of the set, and gives this to the 'Art Director'.

Q) What does the 'Art Director' do?

A) They implement the Production Designer's plan, arranging the interior of the set to fit it.

Well, there are many, many more roles; these are a few of the main ones. There are also costume designers, wardrobe assistants, makeup and special effects teams, caterers (*very* important), and loads more. If you know a little bit about what they do, and they know a bit of what *you* do, then surely this makes for a more harmonious working relationship.

Oh, and remember: always be nice to crew. They are there for you.

'Doing' the Other Stuff

Here are a few back-to-basics ideas you might like to think about again. With your 'daemon', or whatever you will, now in the driving seat, you will engage with your toolbox in a different, much more powerful way. You will also realise that you probably don't even need it, as you will be hitting the mark every time anyway. Always good to have a tool box though. Just to remind you, I said at the beginning of this book that the methodologies did have their place, but were empty if not approached from the 'special' you, which you are hopefully now aware of.

So, leave the powerful inner stuff to the powerful inner self, and trust. Here's a word on the other stuff.

Creating the outer circumstances:

Method actors do a lot of work 'excavating' the inner character (I use the term 'character' here for convenience only) using techniques such as the exploration of affective memory, the unearthing of the character's needs, employing substitution, or asking the question, 'What if', etc. All good stuff.

The thing is, as human beings, we do not exist solely in the inner world. We also have an external side to us: an outer expression of what we are. It's the way we move, the way we speak, our facial expressions, body

language, and so on. For the most part, this will be born of the 'inner'state. We've known about the body-mind connection for a long time, as well as how one affects the other.

Close your eyes and think about eating a fresh lemon. I guarantee that there will be a physical reaction to your thoughts, in the form of your mouth watering. So, we know that our inner state will affect our outer being. It's the same in our work as actors; your inner state will influence your external state, and vice-versa. If, when working on a scene, you need to explore great joy, then it's unlikely that you will adopt a stooped standing position and a downcast expression. You will probably stand up straight with a big grin on your face; both of these things release endorphins which promote a feeling of wellbeing. If your character is a Marine drill sergeant with a mean and hard inner spirit, you probably wouldn't choose to give him the voice of a sensitive effeminate guy from Greenwich Village and the movements of a ballet dancer. However, if you did make these bold choices, you wouldn't necessarily be wrong in doing so.

Villains in reality, for example, don't speak in a gruff voice out of one side of their mouths with gritted teeth. Some gangsters are highly educated, funny, charming, and speak perfect 'R.P.', (English with 'received pronunciation'). but are in fact violent, dangerous men. There are no rules as to what fits with what, but most of the time, your outer state will

be the naturally born extension of the inner. We create the 'inner' world, then by living within the given circumstances and being there, etc., the 'outer' in many cases will follow naturally.

There are a couple of explorations we can try to explore the outer circumstances further.

HOW WILL YOU WALK AND MOVE?

Well, there are a few ways to connect with this. Assuming we have already been open to what 'just comes along', as a result of our inner work, then you can also try the Animal Exercise. Many of you will know all about this already. But for those of you who are not familiar with this great little exercise here it is in a nutshell.

Go to wherever you can see some animals live! Not on the net, or on TV, but live, in the flesh. The zoo, maybe a wildlife park, or just out into the countryside. Now look for an animal you like (me, I love *all* animals), but find one that you are *drawn* to. Now observe this animal in great detail — how they move their eyes, how they lick their lips, exactly how they walk.

Which leg moves first, and how many legs are off the ground at any one time? How do they sit or eat? In detail, how do the jaws move when chewing? You can continue this almost endlessly. If this is an animal that walks on all fours, then you now get down on all fours and copy the movements of your chosen animal in detail. Look at their muscular

movement. How do they blink? Fast? Slow? Get into the 'mind' of the animal. *Become* the animal. Do they seem laid back, or nervous?

After around 10 minutes, slowly stand up, but do not let go of your animal. Walk around, but still retaining the characteristics of your animal, humanise it all. Keep the movements. A Meerkat, for example, might be quick and jerky, or a three-toed tree sloth may be slow and mega relaxed. A Rhino will be big and bullish, clumsy and aggressive. Now we have the making of a role. Let the animal inside you out, but in human form. What animal would you say a Mafia enforcer would be?

So that, in brief, is the animal exercise.

HOW WILL YOU TALK?

Well, what's wrong with the way you talk *now*? If you are playing a doctor, for example, how does a doctor talk? Why not just like you? Perhaps your role is that of a factory worker from Liverpool and requires a strong Liverpool accent. You would need to be able to do Liverpool very well. My thoughts on accents are that you should avoid them unless you do the accent as well as a native speaker. There are lots of great actors from Liverpool who could fit the role, if you can't match that particular accent.

Costume is a thing to be considered carefully. Talk to the costume department. Why do you wear a leather biker jacket for this role? What

does this tell us? How do they wear it? How does wearing this affect their mood, and thus your movement? Wear the costume, connect.

Also, our location will have a bearing on how we feel, and therefore how we 'manifest' in the world. Develop an awareness of the location of the scene (see the chapter on **'psychogeography'**) What is the temperature? Are we in the Antarctic or on a beach in 40-degree heat? This will affect our physicality. Yes, I know some of this stuff is reminiscent of Method actor training, which as I have already said provides a powerful and effective set of tools that can make for dynamic acting, *but only when we stop imposing the system onto our acting, and let the inner craftsman* direct the process as we step aside.

WHEN DO I START WORK ON THE OUTER CIRCUMSTANCES?

A lot of actors leave it to the last stages of rehearsal. How can you make decisions about how you will talk/move before you know a bit about which part of you needs to surface? Others say that if they get the walk, for example, they can build the rest from this foundation. I guess it's up to you, but do it!

The Script:

Read the full script. It's unbelievable how many actors just do not bother to do this. They only read the scenes that they are in. The philosophy

behind this is that if they are not present in a scene, that scene does not concern them. What other people do when they are not there is nothing to do with them as they would not know about it.

In a sense, this is true. What your friends are doing right now has no bearing on how you will think or behave in this moment, reading this book. However, in a script, what they might be saying about you among themselves may reveal something about you. They might refer to the fact that you just got out of prison, for example, something that perhaps is not referred to in any of the scenes in which you appear. Or they might talk about how they feel about you, saying that "He is always so angry". All of these things will inform you.

If this last example were the case though, I think it would be a mistake to constantly play anger. Simply take on these facts about your role and see what your inner voice comes up with. We know it is a fact from the script that your friends think you come across as always angry, but it does not necessarily follow that you actually are. At this stage in your script analysis, we are only concerned with hard facts. That your friends think you are angry is a fact. To say that you are *actually* angry is an assumption.

This brings us on to the next part of your script reading. Once you have read the script, go back and read it again, this time highlighting the facts about your character as written.

Who are you?

What are you?

Where are you?

When are you?

Only use the facts the writer has provided. Do not guess, impose or assume — the facts only.

Your name is Steve/Sandra.

You are 30/70 years old.

You live in New York/Scotland.

You are married/single.

> *You have a job at the bank, etc.*

You are the Prince of Denmark.

You have a lover called Ophelia.

Your Father has recently died.

You believe that you see his ghost.

You live in a castle called Elsinore.

Your uncle is having an affair with your mother.

Your name is Hamlet.

Get the idea? No guesswork or impositions:

The hard cold facts only that the writer has very clearly written. Go through the script and meticulously ferret out the actual facts. No guessing, no assumptions. The *facts*! What other people say may or may not be factual, but it is a fact that they *say* it. These facts will inform you about the role. Now put all of this inside and then let your instinct take over. Stop thinking about it.

Now look for what you need from the other actor in the scene. In life, we all want something from the people we interact with. This is no methodology; this is just life. The thing we need is more often than not very ordinary; something like, "I want you to agree with the point I'm making", or "I want you to like me". Keep it simple. If it is complicated, simplify it.

You need money to pay the rent. That's it. Don't concern yourself with how you will feel if you are evicted and made homeless so that your need then becomes 'not to be evicted'. Just keep it simple. You need money for the rent. You want a loan. Your subconscious will look after the implications of not getting the money. Leave that to your 'other self' and just concentrate on the need for money. Keep it simple! Now go for your need. This might or might not inform the way you speak or behave. We need to get a loan from a friend, so we may decide on a course of

persuasion which we bring out in a variety of different ways, but however we strive to achieve this will be how we go about winning our need.

Be open and vulnerable. Even if that impulse is inappropriate, just do it anyway without thought. If you think about it and then do it, even if you only think about it for a second, then you risk censorship, and it will cease to be an impulse; it will become an idea. You will be acting on an idea which means you will be getting in your own way. The impulse your 'other self' comes up with will be good; trust it! Don't think about all of this too much; just allow it through. If it comes, it comes. If it doesn't, that's OK. Nothing is something. A real nothing is better than an artificial something!

Rehearsal:

Rehearsal is not about being some intolerable prima donna displaying to everyone how wonderful they are, how tuned in to the director they are, and how they have a deep understanding of their 'character' and the production they are lucky enough to be part of. So why then, are so many actors so far up their own backsides that this is how they come across? It's dark up their backsides, which is why they have no vision. Do not be one of them.

So, what *is* rehearsal about, then? It's about exploration, experimentation, telling yourself it's OK to act on your impulses, having

the courage to run with your feelings (which may be different every day) depending on how the other actors are reacting to you, and it's about the blocking. That's about it. Leave the arty, creative, emotional stuff to the child inside. They know how to do that stuff, as we have discussed. Be brave, be true and trust yourself. Who else are you gonna trust? Some other actor in some other scene and his obsession with a clinical methodology? I think not.

Another thing about rehearsing is honesty with the other actors. I don't mean about their process or their acting. It is not your place to comment on these things; leave that to the director. Likewise, it is not the other actors' place to comment on your process.

When I say be honest with the other actors, I mean be honest about *them* and how you feel about them. If they have something about them that annoys you, then say so. Tell them. Clear the air, and do this out loud during the rehearsal. For example: if, when you are delivering your lines to them, their eyes glaze over like they are not listening to you, and they keep averting their eyes away from you, then say something.

"Hey, are you listening to me? Look at me!"

"Are we doing this, or are we pretending?"

By doing this, you are not commenting on their working process; instead, you are calling them out for not being present in the scene. This might

cause a bit of tension, which could well be just what is needed to bring life into the scene. So speaking your truth can never be a bad thing, and it is not personal; it is solely part of your rehearsal process. When rehearsals finish, you are all friends again. Dispense with ego. Do not try to impress on the other actors, or the teacher/director how good an actor you are. What are you trying to prove? You have nothing to prove to anyone, least of all the other actors. Just allow your inner spirit to run free, and see what you come up with, and if the other actors don't like this, then they can lump it, as the saying goes. They'll just have to work with it, as you will have to work with them and their process.

I have suggested throughout this little book that you do nothing, but trust to, and leave it to your special self. But if you must do *something*, then here are a couple of good ideas that will look after the practical stuff. Do not think of this as part of some methodology. This is merely adding a cherry on top of the icing so to speak.

1. Go to an accent coach and get a couple of accents behind you. Make sure they are perfect, and every bit as good and convincing as a native speaker.

2. Attend voice classes. Keep your voice in trim. There are plenty of voice coaches all over the world. Wherever you live, be it in the UK, the USA or anywhere else, you will find a voice coach, and there are plenty of books in print on this already without the

need for me to write an instruction chapter on this very specialist aspect of acting.

3. Exercise. Keep supple, and do stretching exercises, or whatever physical movement you can manage.

Develop other skills: horse riding, dancing, stage combat, juggling — anything you can add as a skill on your CV. Never lie about this. If you say you can do a thing, make sure you can do it to a reasonable standard. I heard about an actor who said at an audition that he could ride a horse. He was delighted when they offered him the job, but he had lied, and when he got out on location on the first day of filming, it turned out that the first shot required him to gallop across fields in full armour. He could hardly sit on a horse, let alone ride one. Well, this caused major problems; he was sacked immediately and replaced that same day. His agent removed him from their books, and it took a long time for him to get another agent. Shame, because this guy was a good actor. He was also stupid. Do not make the same mistake. It's very easy — just be honest!

Here's a little story about Marilyn Monroe (real name, Norma Jean):

She was walking in Central Manhattan one day with Billy Wilder, who had directed her in the movie, *Some Like It Hot*. At this time, Miss Monroe was a huge star, but no one seemed to be taking any notice of her; it was as if she were invisible. The great director pointed this out to her, saying

that these people must be blind and that he couldn't understand why they weren't being mobbed.

Marilyn said the reason was simple. "I have a knack", she said.

"But what is it", asked Mr. Wilder.

"Well", said Marilyn, "Right now I'm being Norma. Watch now when I become Marilyn".

Billy Wilder never quite knew just what she did. There was no visible change, but immediately they were surrounded, and the entire street erupted into a frenzy of excitement.

Make of this what you will.

A Recap

Some Reminders:

- Acting is a kind of magic. We must inject a little more of ourselves into our magic and a little more magic into ourselves.
- "The Tao that can be explained is not the Tao".
- To be in touch with yourself, you need to *get out of your own way*!
- *Do not* impose **anything** onto yourself or your work as an actor.
- Your true, inner spark knows best, and is right every single, solitary time — every Time!
- We must drive the acting methodology, and not let it drive us.
- We should not work for a result. The result will take care of itself when we allow our original, authentic self to drive the process.
- We are all of us already actors.
- What 'system' do you need to be real?
- Why not let the magic of inner truth simply emerge?
- Truth already exists. It is not created or conjured, nor accessed by the use of 'parlour tricks'.
- Just be *you*! Unreservedly, unapologetically and unceasingly! This is not rocket science. You can only ever be *you*! Everyone else is taken.

- Without connection with this 'self' that I speak of, the methodologies will be empty, clinical, paint-by-numbers systems.
- Your work should come directly from you and not from the constraints of some hit-and-miss methodology. Methodologies are fallible; your truth is not.
- Acting is a state of mind, an understanding of a primordial self-awareness.
- It is an experience of understanding inside, and not an analytical or intellectual process.
- In order to create truth in an imaginary situation like acting, you can 'mean it' if you get out of your own way, stop thinking, and don't get bogged down with systems. Just trust in, and leave it to, the truthful and honest original self. Listen to your inner truth, that inner voice, and it will never lie to you.
- The methodologies are OK and can be useful tools, but you must engage with them in the right way and from the right place — on a higher level. We achieve all of this when we put our instinct, our inner voice, our daemon, our guardian angel — call it what you will — in the driving seat.
- Dispense with ego.
- Develop a sense of place, both inside yourself, and geographically. Know where you are at this moment.

- Without your 'daemon', the methodologies and systems are clinical paint-by- numbers techniques.
- Typecasting is inevitable. Get used to it. Accept it, and embrace it.
- Know thyself.
- To be ready to receive, you need to be in touch with yourself.
- To be in touch with yourself, you need to get out of your own way!
- To get out of your own way, you need to trust and stop thinking.
- DO NOTHING!
- There is no such thing as the character. The character does not exist.
- What methodology does it take to look at someone and simply say, "I love you", and mean it? When you can do this, magic happens.
- We must develop an awareness of place, be that place physical, emotional, or fictional.
- Invite the child within to come out and play.
- Be open and vulnerable.
- Daydream.
- To look for 'The Character' is like the blind man in the dark room looking for a black cat that isn't there! Some actors manage to

find it, but all they've found is a comfortable way to pretend. There is no character to find. The character is *you*!

- **There can be no mistakes if we allow the daemon to sit in the driving seat. We only have to get out of our own way.**
- Rehearsal is not about being some intolerably boring prima donna who wants to display to everyone how wonderful they are.
- Our daemon is the author of our creativity, the driver of the machine. It is the inner force, the architect of our magic — our artistic inspiration.
- What are Art and creativity, if not magic?
- *Truth* is the creator.
- Truth has its own status and does not require your belief.
- *You* are far more interesting just as you are than any made up false piece of pretence.

An Afterword

As I hope I have made very clear from the outset, I am not being disrespectful to acting teachers. Indeed, I myself continue to take classes and have some fantastic acting coaches that I go back to time and again.

Also, just to make it abundantly clear: when I use the term 'magic', I am not talking about some sort of sensationalism involving goat's heads and black robes. No, I am talking about the very real magic of creation. Plucking from airy nothing a concept or idea, and then making it real in the real world, by charging it with the magical madness and power that comes from within the deepest core of *you*. We make up stories, and then we bring truth to them. How is this not magic?

Neither am I trivialising the methodologies and techniques. I am simply suggesting that the teachings need to be engaged with on a certain level to be effective and that it is only by working from your special secret place that you will be able to do this. Anything short of this the teaching will be less effective.

I suppose if I were to summarise this little introductory primer to being-ness, my summary would simply say: 'Relax, be aware of the real you and believe in yourself, and don't be driven by any outside influence'. I'm guessing though that you probably would have preferred just a teeny bit

more explanation than that. I hope that I have done so. It is simplicity it's self. Sometimes the simple things deserve discussion.

The fault ultimately does not lie with the teachers or the systems. The fault lies with the student who has not prepared themselves to receive. The preparation is simple. Push ego to one side and listen to yourself. This is stuff that cannot be taught. You already have it. Just release it now, and dance like nobody is watching, and who cares if they are?

'There is no beauty in perfection'.

Sweet dreams and happy days.

Lightning Source UK Ltd.
Milton Keynes UK
UKHW020727070321
379909UK00005B/66